CW00530024

"Just Pots"
CHRIS CARTER
A retrospective

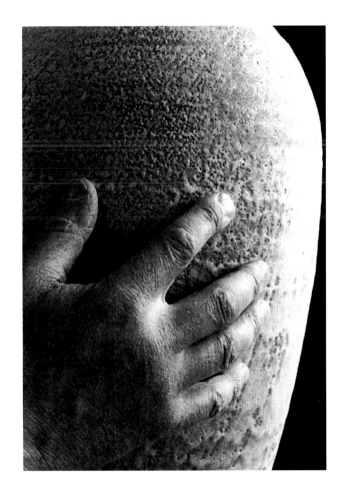

Pots & artwork by Chris Carter

Text by Stuart Dickens

Stenlake Publishing Ltd.

© Chris Carter & Stuart Dickens, 2016.
First published in the United Kingdom, 2016,
by Stenlake Publishing Ltd.,
54-58 Mill Square,
Catrine, Ayrshire,
KA5 6RD

Telephone: 01290 551122
www.stenlake.co.uk

Printed by Blissets,
Roslin Road, Acton,
W3 8DH

ISBN 9781840337549

**The publishers regret that they cannot supply
copies of any pictures featured in this book.**

Photographs courtesy of Gary Kirkham; Richard Littlewood; David Cousins, John Hart, Chris Carter, Martin Green, Richard Stenlake; Stephen Anderton; Arthur Pickett.

Special thanks to…

Stuart Dickens for his input, friendship and understanding in the preparation of this work; Matthew, Tom & Sarah Carter for all their help and work establishing the website and cataloguing of pots; (Mrs.) Kathy Lee; Callum Johnston; and all those friends and family, for their love and support over the years.

This book is dedicated to my wife, Jennifer whose love, loyalty and support has sustained and inspired me.

<div align="right">Chris Carter</div>

www.chriscarterpottery.co.uk

Preface

I first met Chris at the opening of one of his shows at the Ombersley Gallery. Two things struck me about him. One was the way he talked about his work – less about technical matters and more about origins, influences and feelings. The other was his hands. They had to be the hands of a potter: large, muscular and almost preternaturally vessel-like, easily shaping and embracing a large chawan in their grasp.

Although we had never met before, he is one of those people whose ease of manner makes you feel that you have always known him. It is a cliché I know, but what you see in Chris is what you get. He is honest about himself and his pots, self-effacing and yet with an utter belief in the power that his ceramics have to communicate.

Chris Carter is a deeply thoughtful potter. His pots evolve out of a constant exploration of the potentialities of his chosen material and the powerful connections he makes with landscape and human prehistory. This was most evident in *Out of the Earth* – a major show, not to say event, at Salisbury Museum in 2011 with his friend, farmer and archaeologist, Martin Green. The exhibition arose out of Martin's archaeological explorations of Cranborne Chase, home to myriad Neolithic, Bronze Age and Roman settlements and artefacts. At that time, Chris described the way he searched for his pots in the clay as akin to the archaeologist's search for our history in the earth.

It would be facile to categorize his work as backward looking – far from it. He reflects our early heritage in a way that is entirely contemporary and well able to communicate in any context. This is noted by Cyril Frankel in his book *Modern Pots* about the two Chris Carter pots in the Sainsbury Collection. Frankel reports that the large faceted bronze glazed pot *"stands its own when surrounded by many works of art."*

Standing one's own describes this singular potter as well as his vessels and objects. He works alone, would be the last to describe himself as clubbable and worries little about what other potters do or think. This is not hubris but a reflection of the focus which he brings to the act of making.

This countryman potter, a farmworker's son, is more in tune with the earth than most of us. However, any preconceptions that we might have about the epithet 'countryman' are set aside when we see the elegance of design, high level craft skills, attention to detail and the unremitting creativity of this contemporary ceramicist.

It is a great privilege to be asked to collaborate on this book by one of the UK's outstanding studio potters who, over the years, has become a good friend as well as trusting me to show his pots. I know very well that you have to earn that trust!

Stuart Dickens*
May 2016

* Stuart Dickens is a long time collector of ceramics who became the curator of ceramics at Bevere Gallery in Worcestershire in 2005.

The Potter's Life

There was no history of art or craft in the Carter family. His father was a farm worker and Chris's earliest memory is of sitting astride one of the Shire Horses pulling the plough guided by his father. He vividly recalls the plough and the furrows of exposed heavy North Warwickshire clay. It should come as no surprise that land management and the symbiotic relationship between man and the earth should become the *leitmotif* to his life as well as craft. This comes through in many of the responses he gives to questions about his early years.

He was born in Warwickshire on 12th October 1945. The work ethic was an ever-present element in the Carter household – indeed it still is – and before he moved to secondary education in 1957, he began working part-time at Manor House Farm in Grendon. His role models were the men he worked with and the farmer he worked for during those years.

The empirical rather than the theoretical became a strong element in his way of thinking as experienced amongst his fellow farmworkers. He has always been clear that articulating what one sees in a pot, rather than the technical detail of how or even why it was made, is more important. Anyone who has read Soetsu Yanagi's *The Unknown Craftsman* will be reminded of the writer's exhortation to look at an object directly without interposing thoughts, personal tastes and habits – simply seeing an object on its own terms.

As a youngster I was shy and did not take to centre stage comfortably. I worked in a private way and still do. I have been lucky enough to meet lots of extraordinary people in my lifetime. Quite a few were artists from different disciplines including one or two potters. Most notable amongst them all are a farm worker (my father); a farmer (Douglas Kibble) and farmer, archaeologist and conservationist (Martin Green). Each one has enlightened me by example; my father, particularly, because he was such an honest and hardworking man. My first memories are of him ploughing with horses, whilst I rode as a two year old up and down the field holding on to the hames which fitted on the horse collar. These people, plus my mother, who had such good hands that could make anything with needles, influenced my development most.

I was born into a farming environment. I worked the land and earned a living from it in my youth. At the age of eleven I got a job with Doug on his farm. He was the best farmer I ever met, another very hard worker who I felt privileged to work shoulder to shoulder with until I began making pots full time. It taught me a lot about life and people, as well as the earth itself. The annual cycle of ploughing, sowing, growing and harvesting had been etched into my psyche and I feel it still. Any farmer who loves and respects the land he works, becomes a part of that land. All of my materials – not just the clay – come from the earth and my feelings now are still very close to what they were then. Even as a student I made lots of strange twisting shapes, which then developed into pots. In 1989 I did some work for Warwick Museum. I realised then, that some shapes I had developed were probably influenced by the mould board on the plough which had become imprinted in my subconscious. And still, each morning after a couple of hours work, I take a short walk before breakfast. I do not look for anything in particular, I just enjoy the moment.

I was making things in the same way I do now from the first time I could reach my dad's bench. I can remember stretching and trying to get a hold of his tools and things that I had seen him use. When I could first do that, I needed a good box to stand on and as I began to use those tools my Dad was brilliant. He never said 'don't do that'; he allowed me to handle sharp tools and showed me how to sharpen them. So the next time I took the edge off a chisel I could sharpen it and put it back ready for his use again.

If I wasn't in his shed making things, I was looking for bits and pieces in the woods or over on the opencast where we'd got acres to run around and play on bulldozers. I would find pieces of clay and coal that I could carve. Later, when I started secondary school, I remember being given a lot of slate from a fire surround that had been scrapped. I carved it with an old woodwork chisel given to me by Henry Alcock, another significant character in my life. He was my woodworking teacher and the first person to promote in me aspirations to become a professional maker.

Intellectual curiosity and an innate intelligence secured him a place at Queen Elizabeth Grammar School in Atherstone. During those years, his desire to understand how things worked and making objects from whatever materials were to hand, became an increasingly evident aspect of his personality. On leaving school in 1964, the practical rather than the theoretical influenced his decision to undertake a pre-diploma course at Nuneaton School of Art. Furniture making and design was his chosen subject – examples of his work from his schooldays are still to be found in his home. However, during his first term at Nuneaton, in a weekly ceramic session under the tutelage of Ken Whittingham, he began working with clay, sparking his life-long love of the medium.

I was seduced by clay and fell in love with it and was entranced by throwing… there were no tools between my hands and the clay. I knew something of the principles of firing because of nearby brick and pipe works, but I was gripped by the magic of glazing and firing to high stoneware temperatures, a process that fixes the materials permanently. Ken Whittingham was an excellent craftsman who encouraged me to specialise in ceramics.

In some ways, undertaking a diploma in ceramic art and design at Stoke-on-Trent College of Art was a natural step, given that the city was still the beating heart of ceramics in the 60's. The real added value was being taught by Derek Emms and Geoffrey Whiting (the visiting potter), two of the most influential makers of that period. Chris talks warmly about those years and acknowledges that Emms and Whiting ensured that he acquired a wide range of basic skills. He was to become an accomplished thrower and all his vessels and objects are thrown or thrown and altered. Chris acknowledges that the foundations for his ceramic practice were laid during his time in Stoke.

Hans Coper and Lucie Rie were both very European in their approach, whereas my college teachers were more influenced by the Orient. I felt instinctively more comfortable with the work of Lucie and Hans and with 20th century European artists in general. I was looking for something else and they were the signposts for me – setting my direction of travel, but I'm glad that I was also given a good grounding along the lines of Bernard Leach and Shoji Hamada.

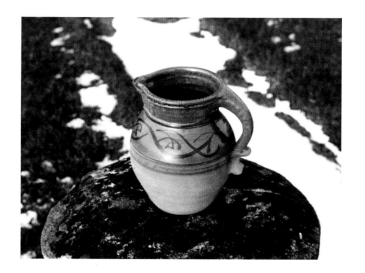

During those early years when I was making terracotta plant pots and stoneware tableware, I spent time researching early oriental glazes, the better to understand the job and the raw materials. This was my foundation and I do not regret it for one moment, although my eyes were looking west as well – to artists like Henry Moore, Ben Nicholson, Barbara Hepworth, Francis Bacon and of course, Lucie Rie and Hans Coper.

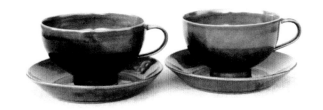

It was the design aspect of Hans Coper's pots that most caught my imagination, especially the pots that had been cut and joined. The idea of architectural building with thrown sections appealed to me greatly. Like Lucie, Hans was a refugee and I admired them both for their courage and independence of thought. Unfortunately, I never met Hans. However, I became good friends with Lucie and with Jane Coper and they told me so much about him and his work. My respect for the man and his work is huge. I first saw the candlesticks he made for Coventry Cathedral when I was still at school. That I have been influenced I can't deny, but my own vision seems to me to be more limited. My pots are born simply out of my passion for the earth. It's true that there is a strong element of design in the shapes but there are far more natural irregularities than I think Hans would ever have allowed.

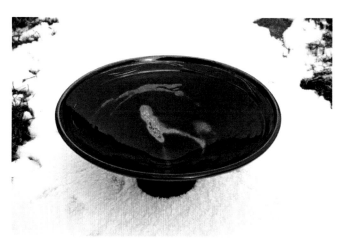

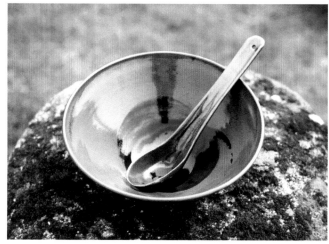

6

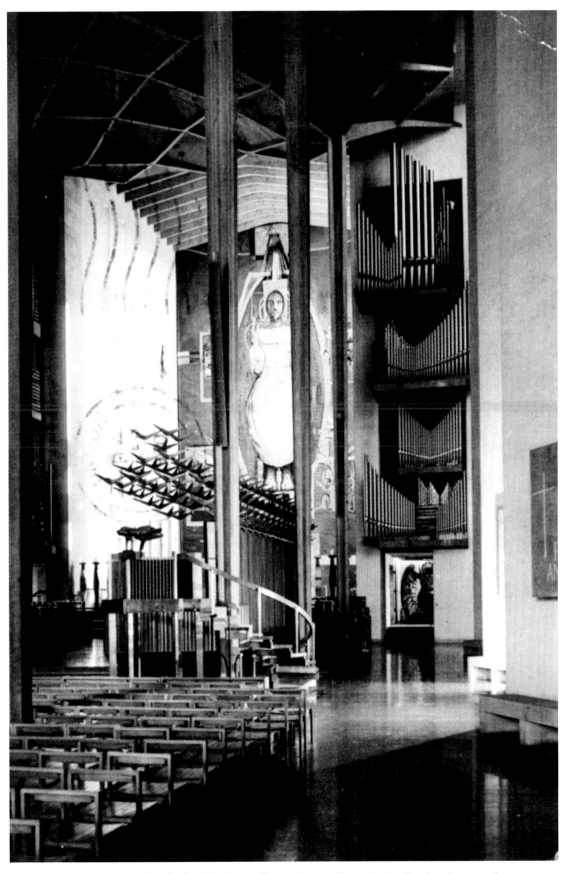

Coventry Cathedral with Hans Coper's candlesticks in the background.
Used with permission of Jarold & Sons Ltd.

Bernard Leach said that good pots are a balance of head, heart and hand. With me I think that my heart is a bit stronger than my hands or my head. Lucie Rie commented on our first meeting that my pots were technically better than hers. This was no compliment! What she was really saying was "Careful, not too much hands!" What I bring to the table now seems to me quite limited but knowing what you've got to bring to the table is as important as anything else in making the pots stronger and much more your own. Lucie was very tough and honest which was part of the reason I loved her so much.

Even while I was at school, Scandinavian design of the 50's and 60's completely bowled me over. Hans Coper's pots had the same effect; I am still excited by them. One of my favourite man-made items of all time is the Viking Long Boat which along with many of the stone axes and artefacts from thousands of years ago are incredibly well designed and beautifully made. I think Hans Coper's work is in that kind of space.

Of all the art and design I have ever seen it is the painting in caves like Chauvet, France that move me the most. Notwithstanding their age – painted as long ago as 32,000 years – they still appear fresh and contemporary. That's where we all come from. They are so honest and powerful and I particularly like the way the artists took advantage of the natural shape and texture of the cave walls. The paintings seem to relate to the very essence of life on earth and my pots are linked to that spiritual feeling we may have for something found within our experience of life on earth. I fire and re-fire until chance or natural selection, call it what you will, gives me what I want. Hans, I believe, on the other hand, went by a different route; but for me it's the feelings I get from the *process* of transformation that excite me the most.

I first saw clean lines, strong simple design and something spiritually uplifting in Coper's work. Less is more. My own pots might begin like that, but I allow natural elements and random glaze developments until the pot does what I want it to.

So, yes, Lucie and Hans deeply influenced me in their various ways, most significantly when I was able to handle their work freely. We never spoke of 'how' only of 'why'. That was all the inspiration I needed – and to be encouraged and admired by Lucie. It meant so much to me then and still does after all these years. It was not only Lucie's magnificent glazes that amazed me but her dedication. "What time do you start work in the morning?" was one of her first questions. I told her that I started at 6 a.m. she retorted "I beat you. I start at 5.30". Her success had as much to do with hard work as anything else was the implication. But now, Lucie, I start at 5 a.m.!

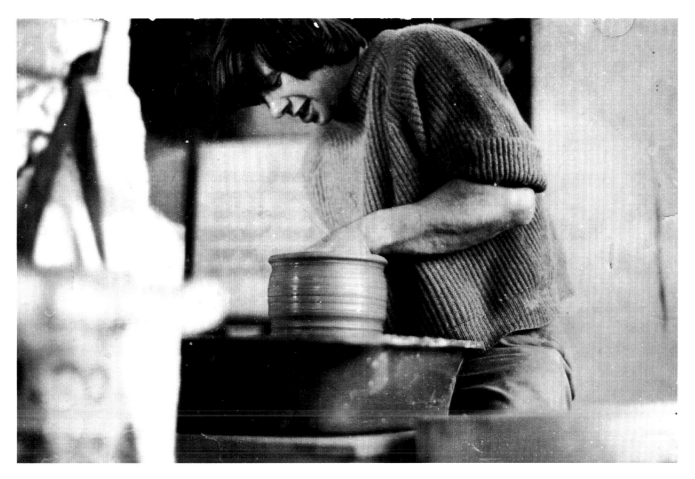

When he left college in 1968 he married Jennifer, who had been an important part of his life since his teens. Skilled and highly motivated as he was when he graduated from Stoke, the responsibilities of marriage and economic necessity determined that finding employment and providing for two was a priority. He began working full-time at Manor House Farm, Grendon as assistant farm manager – thinking about making pots had to be a secondary occupation – perhaps for the only time in his working life. However, when circumstances brought an end to his farming aspirations he began to dream again about how he would establish his career in ceramics.

In 1971 Chris made the courageous decision to set up his pottery at Highfields Farm, Grendon – the workshop that has facilitated his creative energy ever since. In that same year, his first son Matthew was born and there was increased pressure to make and sell his work which at that time was

primarily tableware and terracotta garden pots. The rhythm of life as a professional potter was established and the personal disciplines required of the lone, self-employed maker became the pattern that shaped his life. His working day, when he worked the land, started very early and that has been his routine ever since. When Lucie Rie remarked that she was in her studio well before him, it reinforced the notion that self-discipline and focused working formed the keystone of the maker's life.

For some five years, he managed to eke out a living and then, in 1976, an opportunity arose to build his own shop at Drayton Manor Park. The shop was opened daily during the summer months and Chris gave demonstrations every weekend. The theme park, which had been established in 1949, was beginning to grow during this time and the number of visitors grew exponentially. In many ways this was a rite of passage for Chris – an

experience which today's aspirant potters are unlikely to go through. Regular contact with Joe Public and the need to up his game in terms of repetitive throwing and maintaining stock levels were all grist to the maker's mill. It has to be said however, that he never wanted to demonstrate under such pressure again.

I was building up stocks in the winter for the summer months when we were open, but the deal was that I would demonstrate every weekend, Saturday and Sunday. I found it a hard thing to do in front of such a wide ranging public. Not people who'd come to look at a gallery. These were people who'd come for a good day out in a pleasure park. I was there as part of the entertainment. So, it was a case of kids saying "What you doing now, mister?" "Show us how you make one of them pots up there" and things like that. However, I used to get people coming in like a retired blacksmith who said "Oh, I used to make chains in the Black Country, you know, by hand". Fantastic bloke he was. Little bloke, but with forearms on him like Popeye. So that was enjoyable and it was a good grounding, albeit stressful. I found out very quickly what people liked and what they didn't.

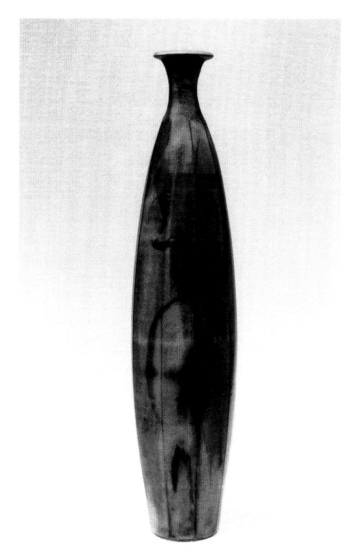

One of the things I loved so much was meeting new people. We got coachloads at the weekend, especially Saturday, from all over the country. They used to come down from as far as Newcastle-Upon-Tyne, a day trip, all the way down to the Park!

It's only five miles, just inside Staffordshire, from my workshop. Everything I made while I was demonstrating, I used to put onto boards which fitted on racks in the car and bring it all back. It was hard work. I find the thought of it now quite daunting, but I don't regret it, not for a minute – and I see those pots sometimes in charity shops. I bought one not so long ago, it cost me more than I sold it for in the first place, I was pleased about that!

His second son, Thomas, was born in 1979 and the desire to break out of the cycle of making for retail grew immensely during this period. Chris spent part of his time working on the development of one-off pieces and by 1985 he was able to produce the kind of work which convinced the widely-respected Peter Dingley to buy in and show his work at his eponymous gallery in Stratford-upon-Avon. After his Drayton Manor experience, Chris wanted to focus on making bespoke work and leave the selling and the associated hassle to the galleries that represented him. The Dingley imprimatur certainly opened doors and soon after he was showing in London at the Casson, Amalgam, Sheila Harrison Fine Art and Cecelia Colman Galleries.

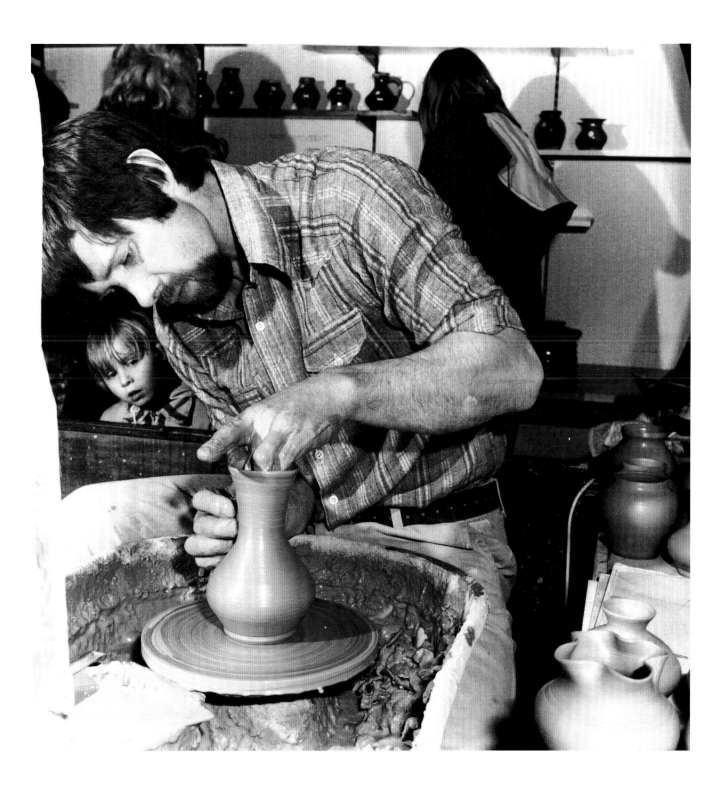

When I first saw Peter Dingley's gallery I realised that although I'd seen many other galleries I had never seen pots displayed so well. I knew then that's where I wanted my work to be seen. My only concern was, was my work good enough? It took me five visits before he bought anything and the first things he bought were some small tenmoku bowls. Peter let me know that the bowls sold quickly, which he knew would encourage me. Because of my experience running my own shop for twelve years, I realised the value of a good gallery and the dedication required to promote and show the work most effectively. That's how good galleries earn their premium.

Selling my work to Peter Dingley opened the door for me to many of the best galleries in the UK including Pan Casson's Casson Gallery, Carole Pimm at Ombersely Gallery, Peter and Mary O'Connor's Chestnut Gallery and Roger Billcliffe in Glasgow. In more recent years, I was taken on by a London fine art gallery, the Hart Gallery in Islington, run by John and Kit Hart, which took me and my work all over the country and abroad. I have been lucky to sell enough in this way to make a living for me and my family – it suits the way I work perfectly. Always close to my heart have been some excellent local galleries like Phil and Leah Evans at the Round House Gallery and the Moon family at Henley in Arden and more recently Stuart Dickens, Curator of Ceramics, at Bevere Gallery, Worcester.

In 1986 he finished at Drayton Manor and his work began to take on a more individual, not to say, bolder look. Chris is open about his influences during this period – Hamada, Bernard Leach, Hans Coper and Lucie Rie but there is little doubt that for him Coper and Rie were the two pre-eminent figures. His was not to be the orientalist route; rather he adopted the essence of these two ceramic icons who had already taken very different paths.

He never met Hans Coper, although he got to know Jane Coper after Hans' death in 1981. He learnt much about Coper's way of working from discussions with Lucie and Jane and developed a huge respect and affection for Lucie as a person as well as a maker. Chris saw at first hand the dedication and focus on the business of making, which he has always tried to emulate and his admiration for these two potters was for more than the wonderful pieces which they produced – it was their approach to making and unwavering commitment which influenced him most. Chris eschews long discourses about the how and why of making. The prevailing sense is one of 'rightness' knowing when a pot is 'right' is what drives his process. That rightness is not to be described in lengthy analysis. Cyril Frankel described Coper's work as being an "offering from his inner self". It is that expression of truth to self which dominates the Carter work ethic.

Every time I took work to a gallery in the early days, I would always pick out what I thought was one of my best pieces and when no one was looking I would put it on the shelf next to some really good pots just to see where I was, how it stood up. And gradually, you can pull yourself up by your

bootstraps like that and you can see things that you couldn't find out in any other way. Peter Dingley always had one or two of Lucie's pots and I told him how much I admired her work and always had done since I was a student. I said to him that I would love to meet her one day, did he think she'd mind if I wrote to her? He said no, of course not! She'd be flattered! I wrote to her and she wrote back, very nicely and said well if you really want to meet me I'm very busy at the moment, but let's make a date for a month away. However, if you want to look at my pots I want to look at yours. I arrived about 45 minutes early because I didn't want to be late, I parked the car and I kicked my heels until exactly three o'clock on the dot. She came to the door. She

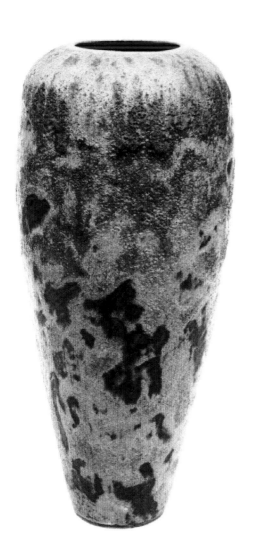

was quite small and I was nearly 6 foot and so she looked up and she said "Who are you?" I said "I'm Chris Carter, I've got an appointment to see you at three o'clock", and she said: "I was expecting a little boy". She thought I would be a student. She invited me in and said "I'm going to go upstairs to make some tea while you look at my work". Her pots were on shelves next to her workshop. I asked her, if I could get pots down and touch them. She said yes, help yourself to whatever you want. After fifteen minutes she shouted down: "Have you finished?" I said "Not really, no, I'm still looking". She said "Well leave them on the table and come up and have a cup of tea and I'll show you some really good pots". I thought, oh gosh, that didn't sound like the same modest lady that I'd been talking to before. When I got upstairs practically every pot up there was a Hans Coper and there was a little pot, one of the spade ones, on the table where she'd made the tea and it was severely in danger of falling over because she'd put a little iris in it, and she said, "He made them to be used, you know". She offered me a piece of cake on an early Hans Coper dish that'd been broken in about eight or ten pieces and glued back together again. It had yellow lines all over the place, but she saw me looking at it and said "you shouldn't throw good pots away when they're broken." "It's a beautiful dish and I will keep it." Then she showed me another pot and she said "I stole that one".

Jane Coper, when I got to know her through Lucie, said the same thing. Hans had a place for his best pots that he knew were ok. Then he had a bin for the bad pots, pots that hadn't worked. Hans worked right on the edge of what was possible and when you do that, every now and then the edge is going to crumble a bit and that's fair. Knowing that helped me not to be afraid of taking risks sometimes. So, he had this bin for those and he had another bin for work he wasn't too sure about. Lucie and Jane used to go through this bin with him. Sometimes they took pots out and said "Well,

we are not going to let you throw that away." I also remember Tim Boon from the Amalgam Gallery in Barnes telling me Hans Coper took round new work to discuss with him. Knowing that gave me confidence to do the same with trusted gallery owners.

Lucie was very important to me because she would ask questions like "Have you got a matt white glaze?". This was on the first visit and I'd taken some pots specially to show her. I'd been collecting these pots for a while to get the best I could possibly show her. There were about three or four of them but no matt white glaze. She said to me "have you got any more pots in the car outside?". I think she'd been peeping through the window because she knew damn well I had. They were the ones that the three galleries I'd been to in London at the time had picked over and had not chosen and so I was a bit disappointed when she said "I want to see those pots as well". She came out with me to the back of the car and straight away she grabbed the biggest one, quite a big pot with twisting facets and I said, "Shall I carry that?" and she said "Do you think I can't manage it?"– putting me in my place! "Bring the rest in" she said, and she gave me a crit on everything. The joy was that her first word on unwrapping the big pot was "Fantastic!" That one word meant the world to me and still does. It's good when gallery owners say positive things about your work, but it's even better when somebody whose work that you admire does.

I particularly enjoy working with artists from other disciplines. I was commissioned to make a pot for Harrison Birtwistle, the composer and musician. I didn't know him then but I found out about his work and what he was doing. Almost immediately there seemed to be a fellow feeling because he too was searching for something different. Music has so much history, as with ceramics, going back thousands of years. To find something that's your own is, to me, the most natural thing to want to do,

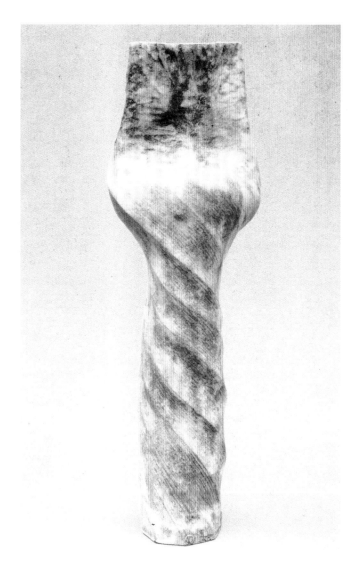

but it's also the hardest. If you want to you can read books that tell you how to make, glaze and fire pots. This is how you do it, these are the best glazes and this is the best temperature to fire at and this is the best sort of kiln to have. Lucie and Hans broke all those rules. They broke the mould and it's to their credit. They were struggling and Bernard Leach was a big friend with both of them but particularly with Lucie and he tried to get Lucie to make pots like the oriental pots and I've seen some of them and Lucie herself said, they were bad, poor pots, and Hans Coper said to Lucie, "Your own pots are better than this. Your own work is your best work. Be true to that".

I needed to fully understand my glazes, so I experimented. I bought the little book on oriental glazes by Nigel Wood published in 1978. Derek Emms thought that it was the best book written on the subject at the time. In particular, it was the analyses of some very early glazes that helped me most. Some were quite low temperature glazes and they weren't all reduction fired, as I had previously thought. They used climbing kilns and some of the chambers were oxidising. I suddenly realised that these potters, thousands of years ago, were making glazes, quite low temperature, oxidised and for me, every bit as good as the most highly-praised reduction glazes of that period.

It was a revelation to make this discovery and to start work on those analyses and not use the glazes that Leach and Hamada had developed from the same examples. I did that research first and then developed my glazes to suit me and fired them in an electric kiln at a lower temperature than normal for stoneware.

I remember the first exhibition I had with Simon Leach at the Chestnut Gallery, Bourton-on-the-Water. David Leach came along with Jeremy. John Leach came a bit later than the other two. Everybody was looking at – or I thought they were – Simon's little tea bowls. They were raku and lovely. David shouted across the room "Johnny, come and look at these. This guy's using similar glazes, firing in an electric kiln at lower temperatures and also selling at lower prices!" It transpired that they were looking at my pots – I thought this response from them was just wonderful.

I had a really good conversation with David later and he suggested that I write an article for *Ceramic Review*. I didn't think that was a good idea at that point. I knew that I wasn't yet ready to write about my work. At that stage, it was my first ever exhibition in a gallery – I knew that I wasn't ready

to start spouting about it, it's not false modesty; it's the knowledge that I had only scratched the surface and the timing wasn't right. You see I wanted to know about the background of those glazes and how they worked in order to build on that knowledge.

It was always this thirst for something new, something different. I'm quite a private person and work in a private sort of way. If I find anything out, it isn't that it's a secret – it's just that I assume that everybody must know that.

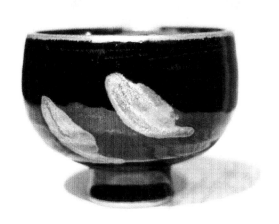

This is a drawing that I made in 1990 taken from various photos. It was lost in the fire along with most of my artwork. I've drawn some of the pots I saw and handled on my first visit to Lucie. That's Hamada at the back, Hans (right) and Bernard (left). I said to Lucie "Did you ever all get together in your workshop?" "Yes" she said "sometimes we did". But actually, what I did, because they were all Lucie's pots on those shelves, I mixed them up and put some of each of the others on there too.

Lucie was wonderful. She used to ask me how I was getting on, because she knew it was a struggle, with a family and a mortgage. If I was in London and didn't go to see her, I would be in trouble, so I always used to factor that in. When I got there she'd be ready with a cup of Lapsang Souchong tea and a cake. She'd say "How are things, how are you doing?" and I'd say

"Yeah, not too bad, not too bad" "Gets easier as you get older" she used to say. "I didn't make any money until I was 60 and then people I didn't know were coming to my door and sometimes they were buying pots from me and then putting them into auction. They used to ask me how much something was and I used to go into the room at the side, round the corner and get the telephone directory and flick the pages as if I was looking through a book to see what the price was while I was thinking how much to charge them." She'd weigh people up, and if they were genuine admirers of her work she knew. Sometimes she would say "Let's have a look at some pots" because she knew I'd been to a few galleries and I would go and get some out the car. She had two nurses later in life when she was not so well and on one occasion called to them excitedly "Look at these pots, girls. Now, this is a good pot, but this is a really good pot, can you

see the difference?" She was so enthusiastic, she was in her eighties at this stage and those two New Zealand nurses, poor girls, gave a hesitant "yes" to her enthusiastic question. It was Lucie's enthusiasm that always shone out. It made me very comfortable to be with her.

During the 1990s his practice developed and as his reputation became established among gallerists and collectors alike Chris acquired a number of important commissions; Potter in Residence for a time at Warwick Museum to produce pieces based on artefacts in the museum; two new pots for the cruise liner *Oriana*; pieces for an office complex in Bristol; for Povl Ahm of the Ove Arup Partnership and for the Almeida Theatre's production of Edward Albee's *The Goat* or *Who is Sylvia?*

There was a pot commissioned on the retirement of Povl Ahm (see page 84), who was Chief Engineer for Ove Arup and was responsible for the building of Sydney Opera House, and also Coventry Cathedral. I went to Coventry Cathedral as a kid with the school when it was opened and saw Hans Coper's candlesticks and was blown away. I was already excited by Scandinavian design. He used to come round to my workshop and we would talk about shapes that occur naturally in nature. He would discuss them in terms of the engineering and he said the architect who designed the Sydney Opera House wasn't responsible for making it stand up. That was his job. I thought that it was fantastic to talk to him – he had names for shapes that changed from round to square. I'm always squashing and changing the shape of thrown pots. Everything begins round, but it's always changing with me because I love the fluidity of clay, the bendiness of it. He would say "That's a so-and-so shape, we used that on a bridge on the M40, round goes to square and comes back to round again". To find out that these things had names and to talk to somebody that was so knowledgeable in terms of engineering was great – so rewarding and exciting.

In 1992 two pots were purchased for the Sainsbury Collection. It is this important acquisition, along with a piece which was added to the Ashmolean Collection in 2008, that established his place in the pantheon of studio potters. In his book *Modern Pots* Cyril Frankel quotes the observations of a well-known visiting artist on one of the Carter pieces "there is certainly boldness and adventure, as epitomised by the large faceted bronze glazed pot standing impressively on the console table beside the stairway leading to the drawing room of Lisa Sainsbury's home in Smith Square. It stood its own when surrounded by many works of art." The power of the individual pot is expressed here and that particular artist's view means much to Chris. The notion of rightness and the authentic expression of self ensure that this work stands four-square amid illustrious company.

The 1990s were a busy period for Chris. He commenced long and productive associations with the Ombersley and Hart Galleries. These relationships epitomised his ideal contract where the love of ceramics combined with high curatorial skills ensured regular sales and a growing reputation. That reputation led to his work appearing through the Hart Gallery at SOFA Chicago (Sculpture, Objects, Functional Art & Design) in 2001, where he was also asked to give a lecture. In that same year, the pots acquired by the Sainsbury Collection were exhibited at the Sainsbury Centre for the Visual Arts and again Chris was asked to talk about his work.

The 90s and early 2000s were, then, a period of consolidation. The boldness which epitomised his pieces grew. He was never afraid to take his work in different directions, responding to his innate curiosity and his connections with the landscape, which remained such a strong force in his life. In 2002 he made a journey to Cranborne Chase – a chalk plateau in central southern England,

straddling the counties of Dorset, Hampshire and Wiltshire – to meet Martin Green, farmer and archaeologist. Martin has his own museum on the farm, which is part of the Chase – just south of Salisbury – and where his family have farmed for generations. Chris has become a veteran field walker under Martin's guidance and his collection of Neolithic and Bronze Age tools is testament to his interest in pre-history. The Chase is, archaeologically, one of the most carefully studied areas in Western Europe and much of the work has been undertaken by Martin himself who won the Pitt Rivers Award for independent archaeology in 1992. Through his endeavour he has built up a picture of the ancient landscape that is hardly matched by any other area in the British Isles. This visit was the beginning of a strong friendship with Martin and the seeds were sown for new work and the intention to develop an exhibition in Salisbury Museum in which Chris's work would provide a contemporary commentary on the rich and diverse past of the Chase uncovered by Martin. However, it wasn't until 2011 that their shared aspiration became a reality.

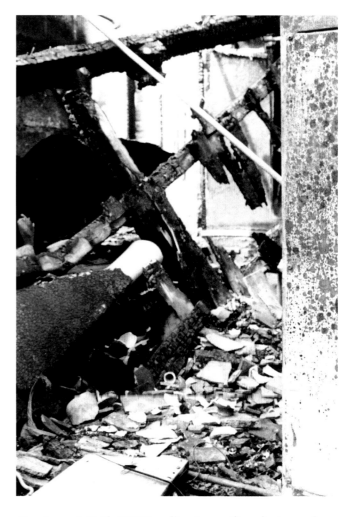

On August 25th 2002 a disastrous fire destroyed most of Chris's Grendon workshop. The destruction of work and material, which in many ways defined his life as a potter and as a student, was a grievous blow. Nevertheless, the Carter pragmatism and acceptance of life's interventions ensured that he was back in full production with a new and bigger kiln by Christmas of that year. There are still tell-tale signs of the fire to this day and grim though the event must have been, in some ways the fire opened another door on the potter's journey. Within a year he held his first Open Weekend to celebrate his recovery from the fire with family, friends and customers who had supported him through this difficult period.

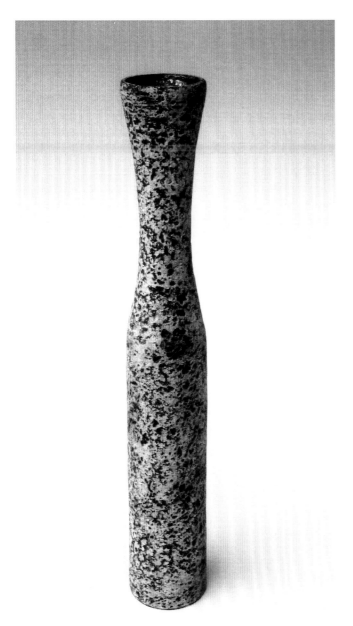

The wind was quite strong that night, it was in the summer, everything was pretty dry. It was a hot summer. I came up the drive. I could see the fire as I approached. There were fire engines down by the pond pumping water. I was just dressed in shorts, a t-shirt and sandals because it was a really mild, early morning. I said "I've got a key!" and ran in before they could stop me and tried to grab some precious bits and pieces. But it was too late. Two thirds of the studio had gone completely, apart from the outside walls, and then the last third, half of that was gone and everything was smoked. I lost my photographs and artwork from school and college. All that went; that was what hurt the most. You can't replace it and no insurance could cover it. Everything that survived was badly smoke-damaged. I resorted to refiring some of the good pots and learnt how to re-fire in a particular way, which I later adopted as part of my routine working process.

I began to turn the situation round, after a week or two. I knew that it was a chance for a fresh start and to wipe the slate clean. Not everybody gets that chance. I'd got two exhibitions already booked. One was for the end of that year at the Ombersley Gallery. Carole rang me up and was very sympathetic and said of course we can cancel. I said no, I don't want to, please don't cancel it. If I've got the show in mind then I shall be busy and I'll be thinking about that rather than the impact of the fire. Fortunately, Adrian Cross from Northern Kilns loaned me a kiln while the new one was being built. So the show went ahead that October. I didn't know quite how I did it, but it was most rewarding. The second exhibition, in the new year, I will never forget. It turned out to be one of the most satisfying. It was put on by Roger and Gill Bettles down at Ringwood. I had had some exhibitions with them before but I really enjoyed this one most. It meant a lot to me then. After those two shows I was back in a routine. I moved across the yard, that's how I kept going. There

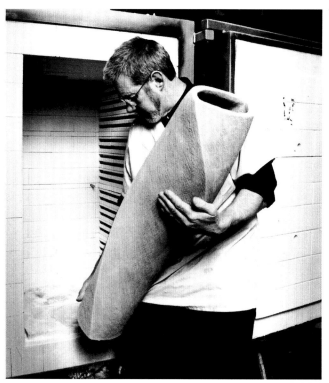

was a building over there that was being converted and hadn't been finished, which Roger and Celia let me use. I'd got a wheel in and carried on throwing and got everything made and ready to be fired until eventually I had my new kiln built. I didn't have to have a kiln until two or three weeks before the exhibition and that was how I got through. A lot of people helped and rallied round, they have done all my life, actually. I've been very lucky with my close friends and family. Indeed in September that year my son Tom married Sarah and that helped to focus and balance my life.

The decade following the fire proved to be one of the most stimulating: his growing reputation was marked by features in various national magazines, journals and Radio 4 on several occasions.

One of the radio programmes highlighted his growing interest in Cranborne Chase and his collaboration with Martin Green and Brian Graham – another artist with a deep interest in the prehistoric landscape which is evident in his abstract painting. Chris and Brian exhibited together in 2004 at Maltby Fine Art in a show entitled *Deeper Down* which focused on Down Farm. Radio 4's *Open Country* brought Chris together with Martin, Brian, Paul Hyland (the poet and writer/artist) and publisher/artist Vivienne Light who has since written a book about Cranborne Chase. During this time the more frequent meetings with Martin and his growing engagement with the Chase itself, reaffirmed their commitment to an exhibition at Salisbury Museum.

I started going down to Dorset to my friend Martin Green's. Oh, gosh, that's a long story. I heard him on the radio. I used to listen to *Open Country* at six o'clock in the morning while I was at work. Make a cup of coffee and start work and put the radio on, Radio 4, and here's Martin talking about Cranborne Chase, the history of it and all the things he's found on his farm. So I jumped in the car one day and persuaded Jennifer she wanted to go down to Dorset for a couple of days and we drove round looking for Martin and couldn't find him. Then I happened to be featured on the same programme about three months later. They said could they do a programme based on the workshop or part of a programme and I said yes, and please will you pass a message on to the presenter of the show Martin was on. Martin rang me and we were on the phone for about an hour and a half. We were just soulmates, we talked the same language. So he invited us to go down and that's how the friendship started. He introduced me to field walking and he's a great expert on flint. Everything I picked up he examined and explained to me.

Going there became more and more frequent and I felt I really wanted to have an exhibition with him

somewhere near his farm. I didn't want it in the Midlands, because it didn't belong there. I spoke to him about it and that's when he said "We'll ask Salisbury Museum, they might be interested" and they were. It took me three years to make the work, then another three months to curate the show and get everything right for it. Although I dreamt of such an exhibition it wouldn't have happened without Martin, I couldn't have done it alone.

The area is so rich in flint and chalk, which I absorbed into my glazes. I already used whiting, which comes from chalk, but I started to use a lot more of it and the same with flint. Most potters use flint to harden a glaze. You might typically use 5% but I was using flint, mixed in layers with layers of glaze and this began to give me sharp, faceted and hard surfaces. But I am a potter and at the end of the day, I have to think in terms of the pots being handled and used so I had to rub those glazes down, I had to grind them smooth again and so a lot of the work for the exhibition at Salisbury Museum was flinted or flinting glazes. You can actually see flakes of flint, that had to be ground down with an angle grinder, then with finer and finer stones and finished off with a diamond pad to make an acceptable surface. Flinted stoneware encouraged me to embrace rubbing down as part of my regular making process.

Each piece starts out like a dream. Each time I make something, it's going to be the best ever. Samuel Beckett said 'No matter, try again, fail again, fail better' and that just sums it up. I go on and on because the shapes I make just grow one from another. I don't do drawings or designs very often. I might be working on one shape, but I'm soaking up other things so that when I begin to make the next pot something might begin to change. I think "Okay, I'll try that" and quite often things don't work. That's one reason I love the wheel. On the wheel I can change things quickly and find things in the clay as I am working. It's not

an intellectual process for me, it just grows out of the previous work.

People might think that I sit down and invent – I don't. I couldn't do that. At college we would have a project to make a teapot or something like that, draw it and make it. I kept changing it and they would say "You didn't draw that. Why have you done that?" "I've changed it because it's better!" "Well you've got to learn to…" no, no, I couldn't do that and the same with decoration. I don't do it, I can't do it. I admire some decoration. I don't draw patterns and design things like that, nor colours. For me, it's the feeling. I came to clay via almost all the other materials before I'd used clay. I suppose I'd played with clay in the garden as a kid, but the things that were accessible to me when I started making things were bits of wood, scrap metal, and cardboard. I'd also pick up loads of bits like I've done here in the workshop that might seem to be just junk, but they're not! Things can be made out of them. I feel something there and I might not know what to do with it when I've got it, for ages, and then all of a sudden, I know, and it fits, and it belongs. And I think it's having the nerve, in a way, to go with that and to know what your strengths are, to know what you can do, and to trust that and be yourself. Doing that work with Martin, in Salisbury Museum and having access to Martin's museum and to be able to handle those objects – fantastic. I feel drawn in. I can identify with the makers and I want to shake their hands. They were more sophisticated than a lot of us. They were fantastic people.

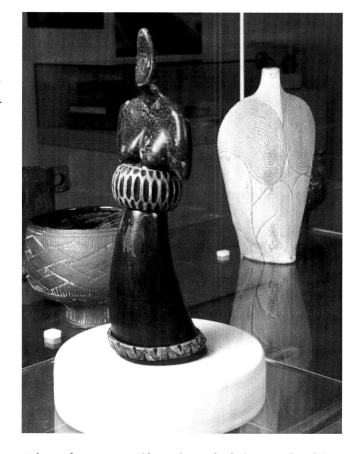

It is perhaps a manifestation of Chris's work ethic that he planned in fine detail the Salisbury show together with Martin Green – to be called *Out of the Earth* – whilst exhibiting frequently at prestigious galleries across the country. He also had an important commission in 2009 from Sir Harrison Birtwhistle, the composer. In the end, this seminal exhibition was, from conception to final curation, the joint endeavour of two men who never lost sight of their goal to effectively reproduce the imprint of 10,000 years of man's interaction with this special landscape. In 2011 Chris spent a total of three months in Dorset working on the detailed preparation of the show.

The exhibition was a great success. Many of those that attended will long remember some of the best work that Chris has ever produced. This preview, posted on the studiopottery.co.uk website, effectively captures the essential spirit of the event:

The exhibition shows new developments in Chris's work and is itself a testimony to the continuing influence of prehistoric people on us today as their artistry, communities and ritual activities are re-discovered through archaeology. Chris describes the way he searches for his pots in the clay as akin to the archaeologist's search for an object in the earth. Cranborne Chase has encouraged his art to take new routes which have seen him sculpting from flint and creating 2D collage works. A deep-seated influence of the landscape and farming is apparent in his work; his pots suggest the sinuous twist of the plough and the symmetry of the stone axe, whilst the surface textures reflect the processes of people and nature on the landscape.

Both pot and artefact have a power and contemplative quality that makes Out of the Earth *an exhibition not to be missed. Here, the passion for the Cranborne landscape and for the people who lived on and moulded it is deep-seated, inherent and heartfelt. The stories revealed are told by two people who know the landscape intimately, both inside and out, and can tell those stories with an authority and understanding that cannot be disputed.*

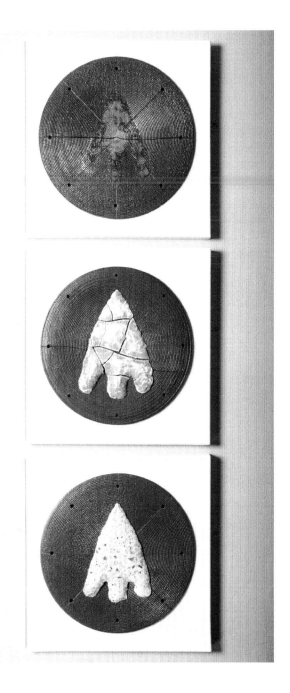

One feature of the exhibition, was the large posters of Chris's poems which had their inspiration in the Chase. He has written poetry over a number of years. For him, the poem is another vehicle for expressing his vision of humanity's custodianship of the world he inhabits. For him the framework of the poem is the most effective vehicle for expressing his feelings about his journey. Read against the backdrop of his life's work it becomes evident that there is a synergy here between word and clay. It is significant that his writing has increased over the last decade, each of his poems infused with a heightened awareness of his place in the landscape and its impact on his spirit.

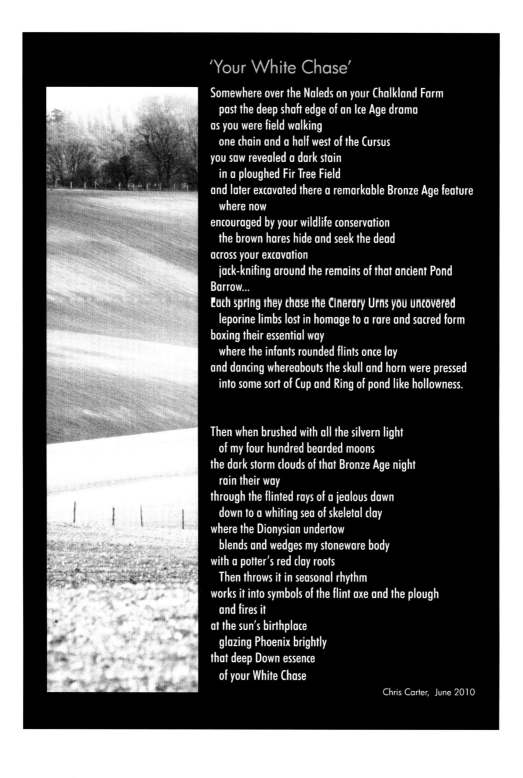

'Your White Chase'

Somewhere over the Naleds on your Chalkland Farm
 past the deep shaft edge of an Ice Age drama
as you were field walking
 one chain and a half west of the Cursus
you saw revealed a dark stain
 in a ploughed Fir Tree Field
and later excavated there a remarkable Bronze Age feature
 where now
encouraged by your wildlife conservation
 the brown hares hide and seek the dead
across your excavation
 jack-knifing around the remains of that ancient Pond
Barrow...
Each spring they chase the Cinerary Urns you uncovered
 leporine limbs lost in homage to a rare and sacred form
boxing their essential way
 where the infants rounded flints once lay
and dancing whereabouts the skull and horn were pressed
 into some sort of Cup and Ring of pond like hollowness.

Then when brushed with all the silvern light
 of my four hundred bearded moons
the dark storm clouds of that Bronze Age night
 rain their way
through the flinted rays of a jealous dawn
 down to a whiting sea of skeletal clay
where the Dionysian undertow
 blends and wedges my stoneware body
with a potter's red clay roots
 Then throws it in seasonal rhythm
works it into symbols of the flint axe and the plough
 and fires it
at the sun's birthplace
 glazing Phoenix brightly
that deep Down essence
 of your White Chase

Chris Carter, June 2010

Since Salisbury, Chris has visited another favourite place of his on the River Lune in the North of England and taken the opportunity to gather selected water-worn pebbles which have been incorporated in a series of pots which are again redolent of another time; they reflect contemporaneity whilst embracing that thread which links potters over thousands of years.

This, then, is the Carter story so far. Objectively, the Salisbury experience seemed like the culmination of an already successful career. This major event in his professional life brought together so much of what defines him – his mastery of his chosen medium, the ability to express the conceptual in tangible terms, the telling of earth stories and the overarching sense of making a small contribution to the history of our landscape. What clearly emerges from his life so far is that there will be more to come and when infirmity curtails the throwing of the clay he loves – hopefully some way off – we can be sure that he will find creative alternatives to express the well-spring of his vision.

Obviously nothing is ever straightforward particularly in this business and I am amazed looking back at just how it all came together. The decisions made at that time were not taken lightly – they also involved my wife and family. One thing is for certain, my career in ceramics and the dream I have always had of searching for something different, comes from that love of the earth. I'm not going to retire! Ever, ever, ever!

Talking About Making

Gary Kirkham, took this photograph of my hands taking clay from the brook on the farm where I worked. I love it. I did a big exhibition with Gary. West Midland Arts gave me a development grant. One of the things they wanted me to do was to give a description of what I was doing and how I was doing it. I thought that might best be done by Gary with his black and white images. I have a great affection for Gary and for those times and what he did with his camera because he unlocked some things for me.

It followed closely the work I did at Warwick Museum. I'd been making pots for twenty years when I did that work and they asked me to choose artefacts in the museum and make some work based on my choice (see page 05). Straight away I was attracted to an early horse-drawn plough. Beautiful thing. I was making twisted pots while looking at this and it was only afterwards, talking to Gary that I realised that this was probably in my gut from the time when I was actually ploughing on a farm and I saw the soil being turned over by the mouldboard of the plough and it's that, the fact that I'd done it without consciously doing it, that's what was so important. And to know that was doubly important, because then, it's like a confirmation that it's right, that it's honest, that it's true, that it's you. So now, I don't worry about these things, because I know they're there and I know they're getting into my work. People say to me "how do you do that?" I don't know! I don't want to know! I just do it. I go a walk every morning and I get about. I go to different parts of the country, but I don't do it with a view to making something that looks like where I am or what I am, I pick bits up and I bring them back, like a magpie, but not to copy.

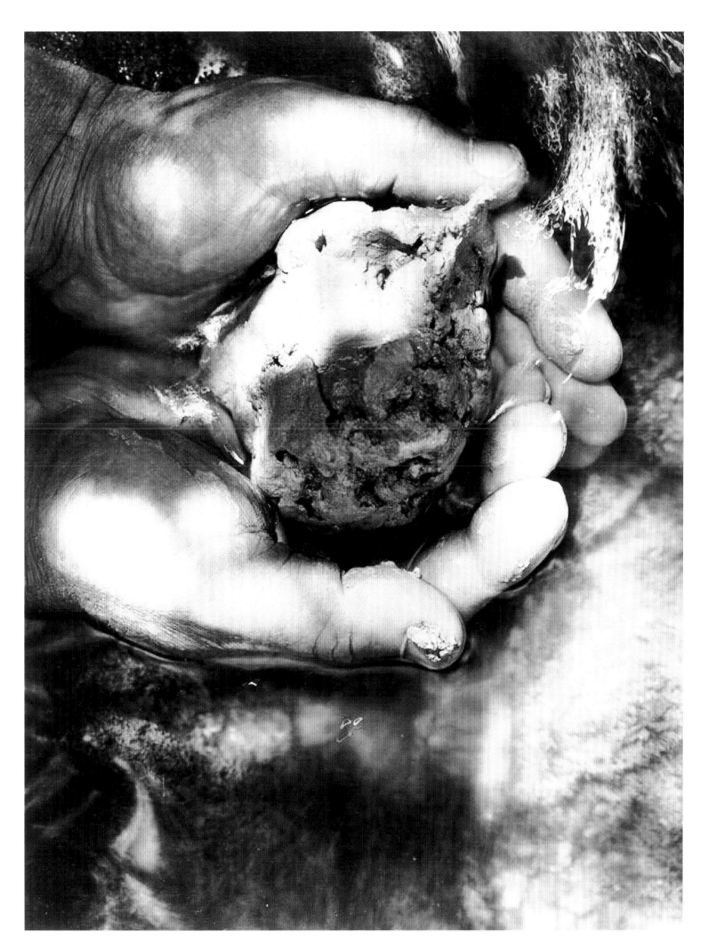

When I work I'm allowing an element of random chance, or the natural selection I see happening in nature, to help find what I want. We all know what an oak leaf looks like, but if we look closely we can see that there are no two leaves exactly the same – there are small irregularities. When I first began potting, I encouraged the landscape and its wildlife right up to my door by planting shrubs and plants along the front wall. Some of my most colourful guests were the little owls. They hunted for the beetles and worms I had also encouraged and left me a present of owl pellets on my doorstep. They were taking what they needed from the land and then regurgitating some of it in a much altered form. It was observing what they did naturally – without fuss – that encouraged me to just do the same. My pots are like those owl pellets in a way. I've always identified with nature and little owls in particular; I think of them as my teachers and guides. I am working for myself. I cannot imagine trying to get my work right for someone else, so I will use anything I find that works for me. It is not an attempt to say something – just a case of selecting what is right for the pot I am working on. I do not sketch or deliberately copy elements of the landscape. I do pick up bits and pieces of it and put them in my workshop to look at, not to copy. When I was farming, there was obviously no time for such niceties, I guess I just soak up what I experience and then work. It is more of an abstract notion and a feeling for the job – a job that has become another way of working the earth.

The pot that I am happiest with is the one I feel least responsible for. It is the pot that makes itself, as if ploughed out of the clay rather than thrown in a sophisticated high temperature body; or it had been washed up on a riverbank like a pebble; or it had been picked up from its hiding place like an ancient stone tool hidden for thousands of years and with the patina of ages.

Laurie Lee, one of my favourite writers and poets, said:

> It was something we just had time to inherit, to inherit and dimly know – the blood and beliefs of generations who had been in the valley since the Stone Age. That continuous contact has now been broken, but arriving as I did at the end of that age, I caught whiffs of something old as the glaciers. There were ghosts in the stones, in the trees and in walls and each field and hill had several. The elder people knew about these things and would refer to them in personal terms and there were certain landmarks about the valley – tree clumps, corners in woods – that bore separate antique, half muttered names that were certainly older than Christian.

'How?' is such an ordinary way of looking at the work. It does not explain anything else but technique, which ought to be taken for granted if the piece has any merit. The life and soul of the pot – if it has one – comes from the motivation. It is the feeling with which the vessel was made, not the way it was made, that matters. My pots aren't made with a price in mind, even though a living is earned as a result of making them. Michelangelo's one time master Bertaldo told him not to make work just because he was clever enough, but only because he must. Much later Michelangelo put it more bluntly – *Talent is cheap. Only dedication is dear.*

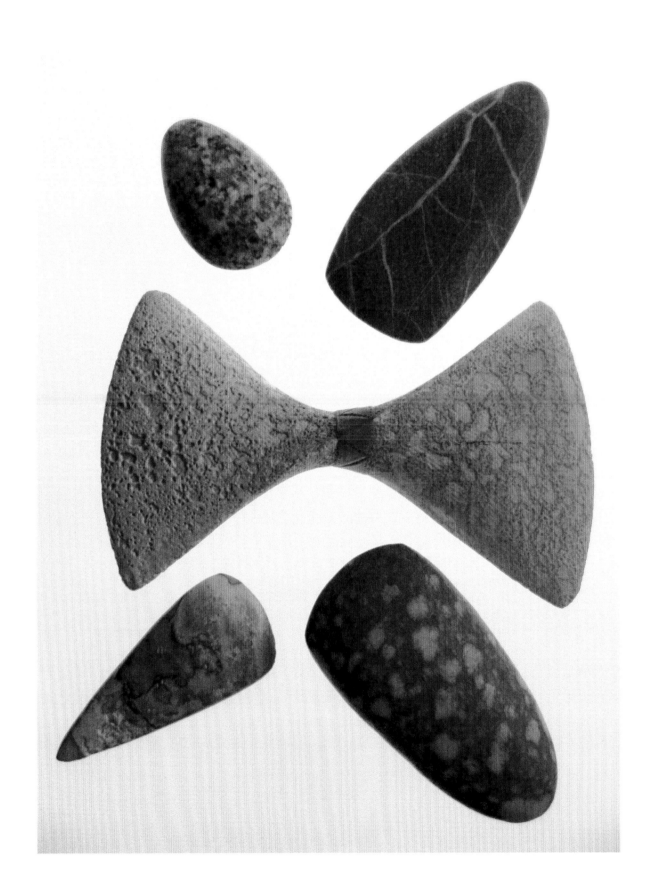

The business of 'Why?' never does go away. Whatever I am doing has a bearing on it – whether it is gardening, walking or visiting a museum – they are all relevant to the 'why' of my work. If you are truly the work then the work is truly you. You do not have to be a genius to see that. My pots are not so much a way of feeling about pots, but more a way of feeling about working the earth.

I get what I want by any means I can. Half my potting is spent unsettling what my hands seem to do with ease. The outcome of this way of working has more reality and inevitably more truth to nature. It is the selection of what fits and what doesn't that matters most. It is the searching for something that happens naturally and does what I want it to; that is my job and I will use anything I can find out there that helps me! I am searching for something that looks as natural as a fallen worm-eaten branch of an ash tree – but I am not making branches. The pot has to be itself.

Development is not something that I sit thinking about. It comes through working and it is what it is. It is not so much restlessness as a constant enquiry and natural growth. A new shape might seem to appear overnight but really it has been incubating for some time. Even in the beginning when I was making tableware, my mugs or plant pots would develop constantly and I would find myself having to look back to make replacements for a customer who bought them a year or two earlier.

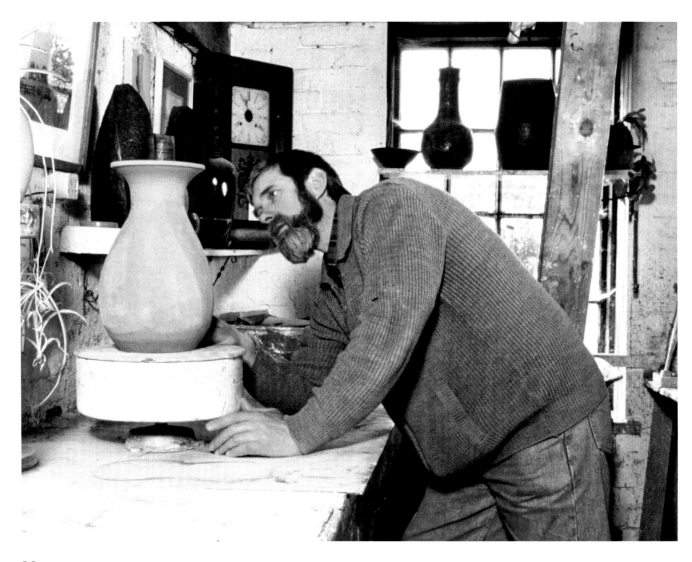

I always had a feeling there was something else out there that I was searching for. That is how it has always been and in a way it is as natural as the growth of a tree in a particular environment. If there is an aspect that I won't let chance take a hand in then it is the functional properties. A pot that might be used for flowers has to be watertight and cleanable – or if I choose to display a stone in a pot instead of flowers the stone must be secure. The nature of my glazes has developed as constantly as the shapes but I am careful that the more heavily textured pieces are not unpleasant to handle. Stability is also an important factor because my pots are for people to use as well as look at. I am a potter at the end of the day! Strength is another factor for me. If it's a bowl then let it be strong enough to be picked up by the rim.

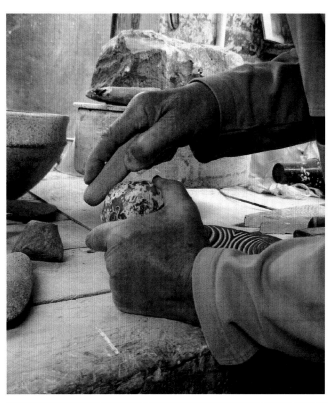

It's this growth or development of my work that might surprise me, not any of the detail that grows out of it, like a rim or the angle of a foot. I work not in a self-conscious way, but by always trying to avoid the inevitable and seeming to let it find me rather than me finding it. Each pot must be complete in itself but it's also looking forward to the next one.

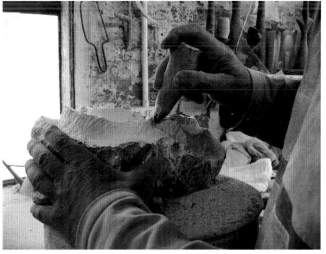

I still dream of better pots to come. I always have and my ambition has grown with age. It is all dreams, that eternal feeling that the next pot will be even better. Every time I open my kiln door, the anticipation, excitement and gratitude is the same as it ever was. So, I have no intention of letting fate take its course with my work. I am still ambitious for my pots, if not for myself where I am more content to let fate take its course.

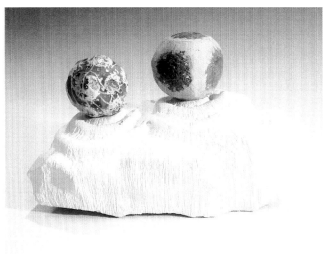

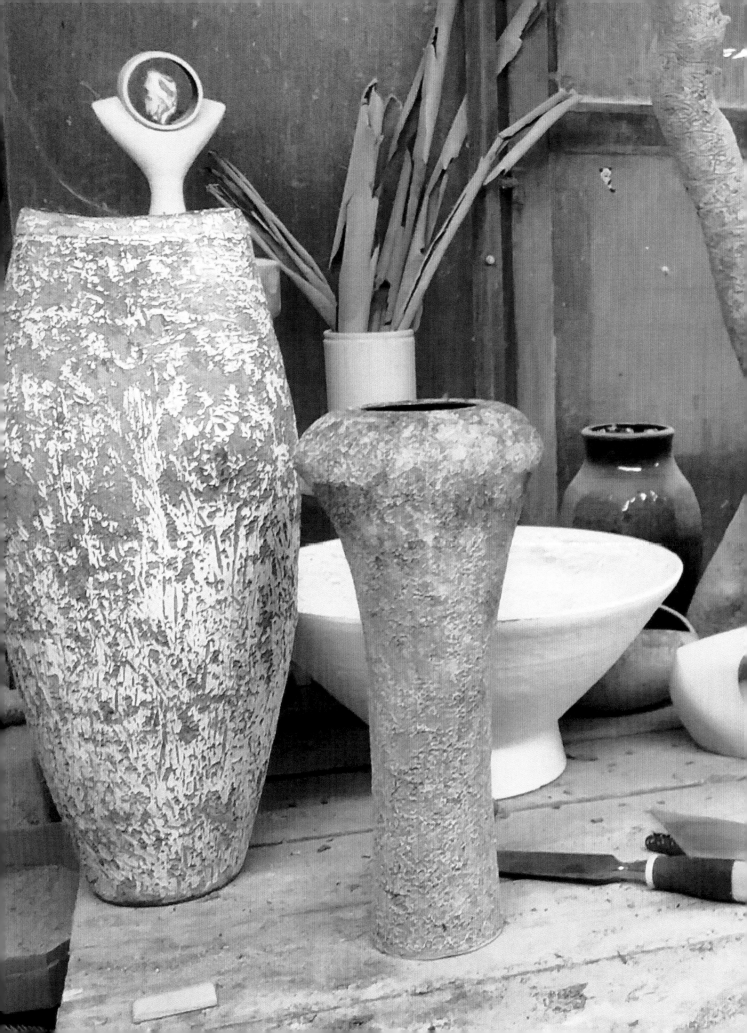

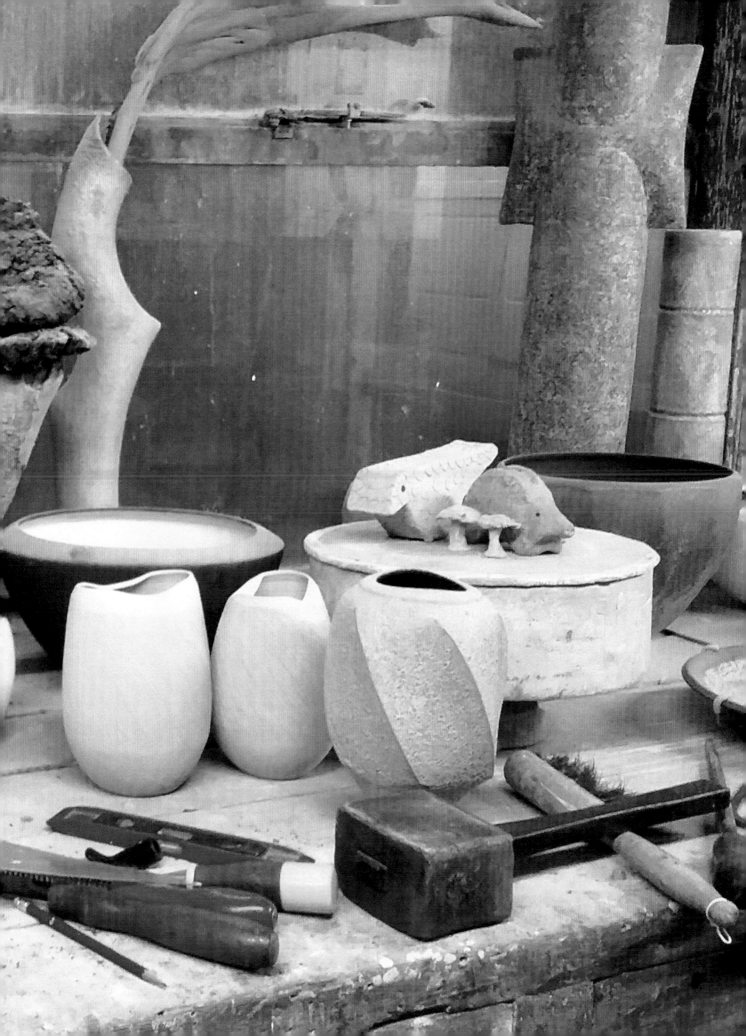

The Countryman Potter

This confuses me. I do not fit any mould that I know of. All of my instincts and natural feelings are rooted deeply in the earth and the farming of it. I have never felt comfortable anywhere else except the countryside for more than a day or two – so I guess my interpretation of 'countryman potter' is a literal one.

It is the earth that nourishes and supports me and it provides a foundation and security just as I imagine it did thousands of years ago when the hunter gatherers first began to settle and farm areas of land.

In 2010, gallery owner John Hart wrote *That men made truly beautiful objects and seem to have made them to be beautiful is something that inspires Carter and guides him. That someone thousands of years ago cared is something that we could all gain by contemplating. It is the start of a human tradition.* He is right and I belong to 'that' tradition. Many of the flint and stone tools that were made then were refined and polished way beyond anything that was necessary for their function; they became symbolic of something much more to their owners.

Archaeologists say that we may never know why the 32,000 years old cave paintings in Chauvet, were made. I can certainly feel something of why they were made, but can't explain it. Actually there is no explanation because the paintings are their own language. It is why I do what I do and when I use the title countryman potter it is the why that I am talking about not the how. Maybe I could call myself 'farmer potter' and would if I still farmed.

My ethos is more private, even primitive if you like. Federico Garcia Lorca grew up with the agricultural workers who farmed his father's fields and he learned from them about the earth that they worked. There is a lot in his writing that I admire and have been influenced by. When I was farming I worked the clay soils and respected them in a way that I am loathe to discard. No label is important it is the work that counts – nothing else – it's just the pots.

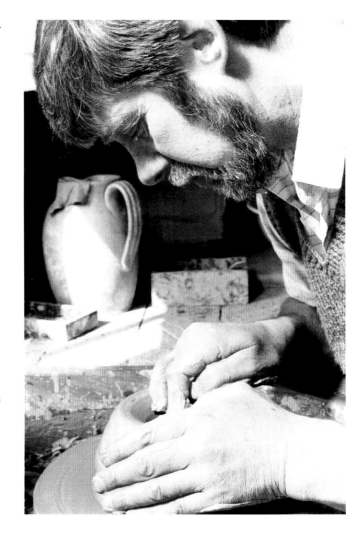

Lorca never lost his childhood memories of those workers who taught him about duende – the spirit of the earth as he later translated it. It describes the love and passion that fuels Spanish flamenco music, dance and verse. I am a countryman and my pots have grown out of traditions as old as mankind, even though they might not be seen as traditional pots. It feels to me as if they are found by instinct as much as designed and I am very comfortable with that.

The analogy of 'ploughing a lone furrow' is clearly apt, but I did not plan to plough a lone furrow; rather to plough one as straight, true and deep as I could. By the time my work was of a standard fit for the galleries where I wanted to sell it everything else seemed to pass me by. I just got on with the job as I saw it. That is my nature I suppose.

There was another farmer I admired, John Dodd, up in Northumberland, who ploughed with horses all his working life. He said he would like to be remembered as a son of the soil. If I could choose, I would like to be remembered as a son of the clay. I suppose, given the circumstances, I was always going to end up ploughing a lone furrow. That's my nature to which I have remained true. It's enough that my pots have travelled the world – they are my ambassadors if you like.

Martin Green is not only someone that I admire but a man that I trust completely with my work and with the understanding of the motivation behind it. His archaeological work is outstanding and his collection of artefacts displayed in his own remarkable museum has stimulated huge amounts of work from me – indeed three years of work for that single show. Work in clay naturally but also flint, stone, wood and pigment.

When Martin and I met, it was immediately evident that we shared the same feelings for the farming landscape – past and present. Suddenly I was with someone who could enlighten me about the first people to begin farming where he lives, land which has been farmed since the last ice age 10,000 years ago. He understood and admired, as I did, the sophistication of these ancient people who made such wonderful objects in clay, stone and flint and also was able to show me his collection of these beautiful objects. He also understood the kind of dedication that leads to good work in any field. I realised that my search for pots in the landscape was akin to the archaeologist's search for our history in the landscape. We were both using knowledge gained over a lifetime's work to piece together our answers.

The exhibition *Out of the Earth* was an idea that I dreamt might happen one day. The fact that it did was as much down to Martin's efforts as my own. It was an exhausting time as he liked to present me with pieces of flint, wood and stone that he knew I would not be able to resist trying to work up into something that we both recognised.

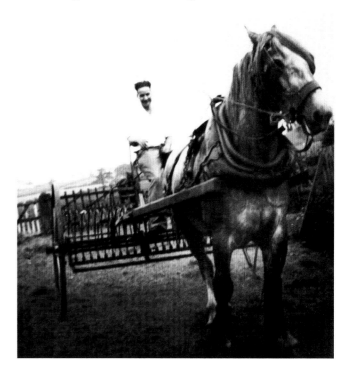

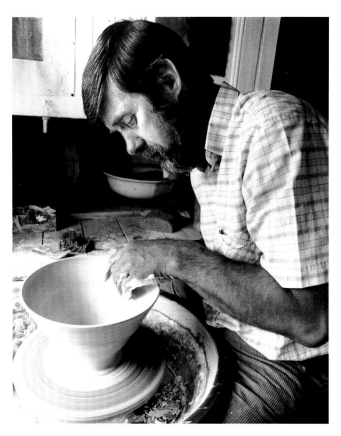

It was on the first glance of a Neolithic grooved-ware pot excavated by Martin from a site on his farm that I was first moved to make a connection with that ancient potter who made it. Not only had they beautifully marked the surface of the, surprisingly contemporary, shape with incised lines but had also uniquely done the same on its flat base. The pot itself is wonderful and its surface strikes me as much like a texture as decoration. That the potter had also taken the trouble to make a feature of the underside of the foot resonated with me because I had long taken as much care with that part of the pot as anything that was visible without picking it up. So I began to make similar marks on the foot of some of my pots, but they are not copies of that pot. I see it as a handshake with that Neolithic potter.

I also made a selection of various new tools to do the work with – some made of wood, some of stone and a couple even of polished flint which took me hours to polish. Another spin off from my association with Martin and Cranborne Chase, where he has lived and studied all his life, is an increased use of the two materials – flint and chalk – that have helped determine the history of that area. Together with my beloved local red clay, they bring a strong character and natural quality to the surface of my pieces.

My connection with the past is just the same as anyone else. I am not special in any way. I find holding objects made by craftsmen thousands of years ago both moving and thought provoking. I begin to identify with those makers and I feel a great warmth for them and their way of life. It's such a privilege to have access to so much important work.

I was first touched in this way in 1989 when, during a residency I undertook at Warwick Museum I found a polished jadeite axe that I based some work on for them. For this experience I am indebted to Eileen Measey who was then Keeper of Social History. I have been pleasantly haunted by that axe ever since. In a way I think my trip down to Cranborne Chase to meet Martin Green began on the day I chose it from a shelf in the archives of Warwick Museum.

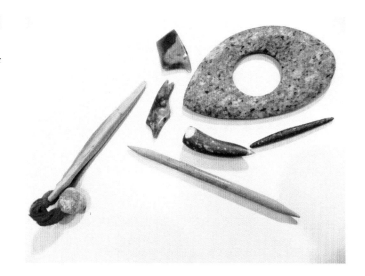

There are certain aspects of a pot that as a potter you cannot control. Those abstract qualities come I believe from the feelings behind the motivation for the work itself. What I do in one sense is quite limited. It is the understanding of that contribution that is important. The random chance that I use to give me the textures and glazed surfaces I want are more fitting than a more deliberate application will give me. As human beings, we often respond favourably to some natural feature in the landscape without any prompting. Perhaps that is something to do with it. It is better for me not to analyse it too much or I might lose it. I like to leave some things unresolved, like reading the first sentences of a paragraph when you are not sure where you are going. Trying to keep that feeling is helpful. It is easy to keep making small improvements to a pot, but it will not necessarily enhance the character and strength of it, which is what matters most to me.

The potter, David Leach always said if a small imperfection was pointed out to him that it was all 'a part of the pot' Dead right! Stephen Hawking says that it is the small imperfections that made the universe what it is and so spectacularly beautiful. That is where character comes from. That is what I love and respond to. Any re-firing that I do is not to get rid of small imperfections – in fact it often introduces new ones – but rather to build layers of character and maturation.

If you look at an oak tree you will recognise it straight away and it fits into the environment perfectly. However, the oak tree growing in a lush meadow is very different from one on a windswept hillside but they are still both right. Both have validity and it is their natural growth and response to the environment that has shaped them. I am certainly not making oak trees but it is something like the oak tree metaphor that guides me.

The form of a thrown pot is fixed early on in its making but its final character is not revealed until it is fired. What will work best has to be discovered with practice and experience. It is a case of letting intuition, chance or natural selection help me to find it. This way the results fit better for me and have more authority than any more formal application of texture and glazes.

I am not looking for something that's pretty or shocking, just something that is as right as the oak tree in its landscape. I am not saying anything – just doing something, which is why I have always got on with my job and let the pots stand or fall, sink or swim. The pots are their own language. This is what my friend David Hart, the poet, said when I showed him a poem which I had written when I was making the work for the Salisbury exhibition. He was confused as to where the words were coming from and why. Frankly, so was I!

My workshop is the hub of my work and has become more than just a space to make pots… it is my den where I am hefted to the earth. I am forever grateful to everyone in the Rymond and Miles families who have become good friends and have allowed me to work here for all these years. For anyone familiar with the work of Kurt Schwitters this is my Merz 'Barn' with its location in a farmyard in the middle of a field and it's where I have grown closest to the earth that I depend on. I love every brick and crack in its old walls.

It is hard to express what the workshop means to me as I am so close to it. It is like looking in the mirror. It certainly feels after all this time that the workshop is me and I am it. I love being close to the wildlife which often comes inside when the door is open. I get birds – even a young jay one year – swallows and blue tits are common, as is the wren and hedge sparrow. I also get butterflies, moths and bumblebees; I keep a net handy to get them back outside. One year I had a hornets' nest in my roof – I am not sure if that says anything about me – and, oh yes, bats have occasionally

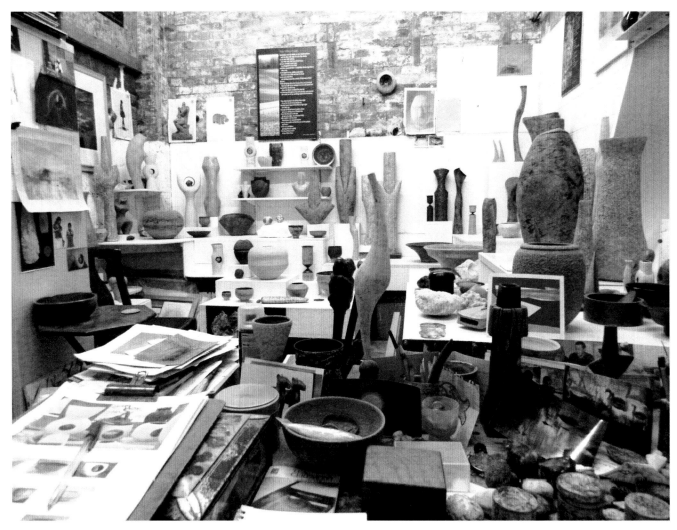

emerged from tiny cavities in the outside wall to startle and amaze me; all that plus the little owls!

It is actually an old stable and has the original cobbled floor which I took up and relaid just as it was, except for the rats living in the ashes beneath it. If I close my eyes and think back I can just hear and smell the massive Shire Horses that once worked this land. Both of our sons grew up coming down here whenever they wanted to as did the girls from the farm. Pixie, our Welsh Collie was always with me, as were her pups Nipper and Shep. Now my granddaughters Emily and Phoebe visit me here. There are the scars of several farm fires which add their character as well and if I have made a few half-decent pots over the years then I know the place has played no small part in that. Visitors seem to love it too. It's always been full of pots – as am I!

If I think where I began as a kid, just making things some of which I still have, from bits and pieces in my father's shed, that feeling is still exactly the same. My dream was to be a maker. I always knew it would be a lifetime's work. My great luck has been to have such a supportive and loving wife, family and fantastic friends who have helped me through thick and thin. I believe that I still have more to learn and more to offer. The tradition that I follow began thousands of years ago with sophisticated people who lived so close to the earth that it thrilled, excited, scared and filled them with awe, wonder and curiosity. And that's how I feel.

If I use the metaphor of the oak tree again, half of the tree is hidden underground. It's the roots that give life to the visible tree and unless they are vigorous and find water it will never thrive.

Understanding this has always been the foundation of my work – it's the "roots" that determine the character of the pots. I don't believe that they are perfect; my limitations are personal and private to me and how I make my pots is not relevant to what you see. I have always believed in letting the raw materials I love help me find new ways of thinking. That is where my confidence in the work has always come from.

In a way, the work finds me rather than me making it. Patience is essential. There is a lot that can be achieved in a lifetime – if I just turn up every day. But if I want to hear the dawn chorus, I need to turn up early enough!

If I have a philosophy at all then it is these words of Chief Seattle:

> *The earth does not belong to man, man belongs to the earth. This we know. All things are connected like the blood that unites one family… Whatever befalls the earth befalls the sons of the earth. Man did not weave the web of life; he is merely a strand in it. Whatever he does to the web, he does to himself.*

Trying to make half-decent pots has for me always involved my deep feelings for the earth. How they are made is of no importance, nor why they are made. At the end of the day they are just pots, nothing else, and all the talk in the world can't alter that. They're just pots.

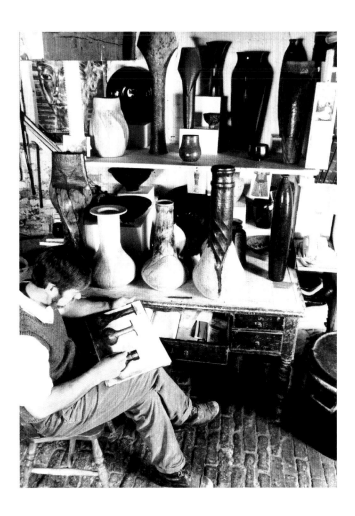

Just Pots

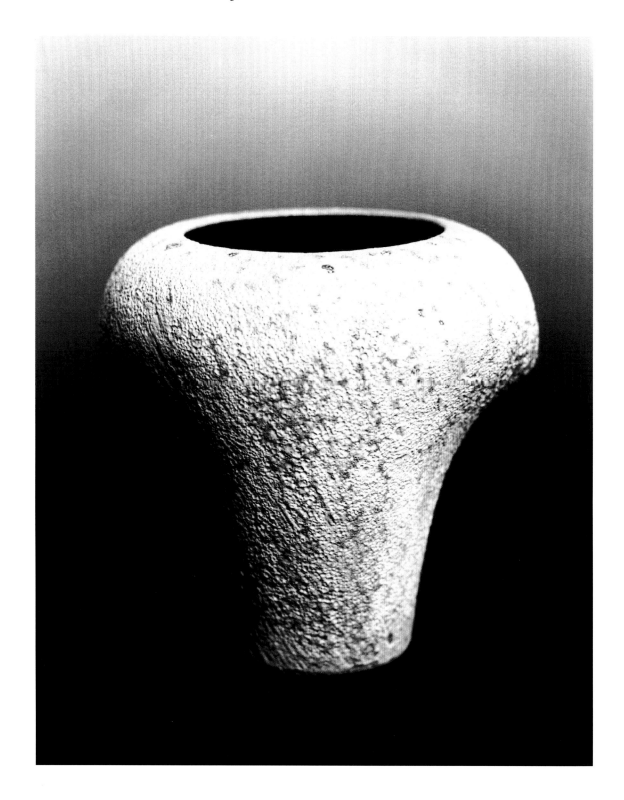

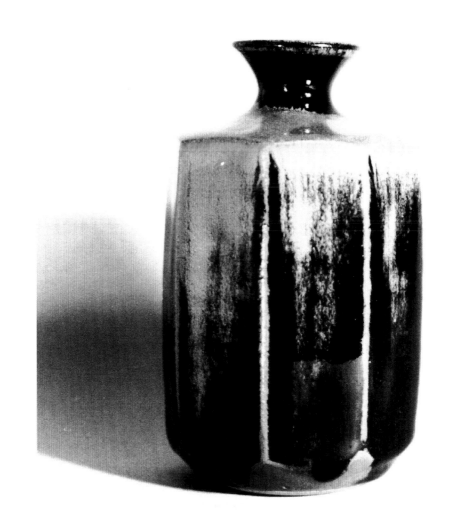

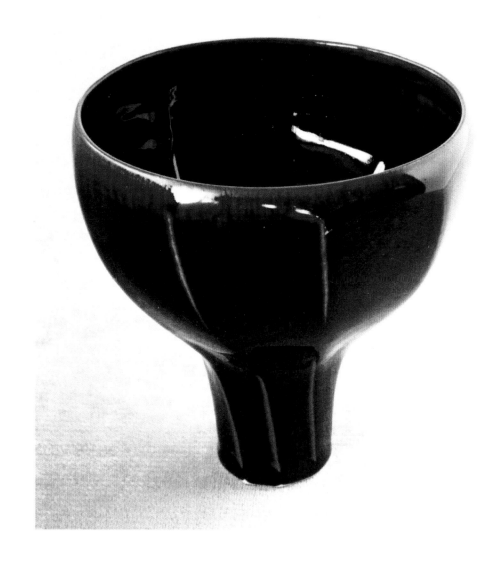

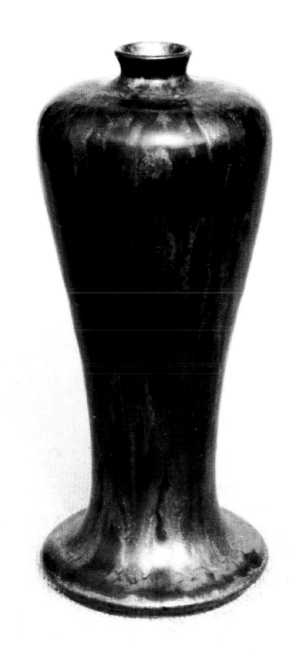

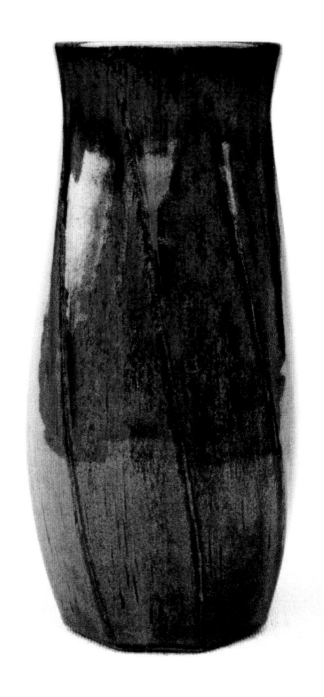

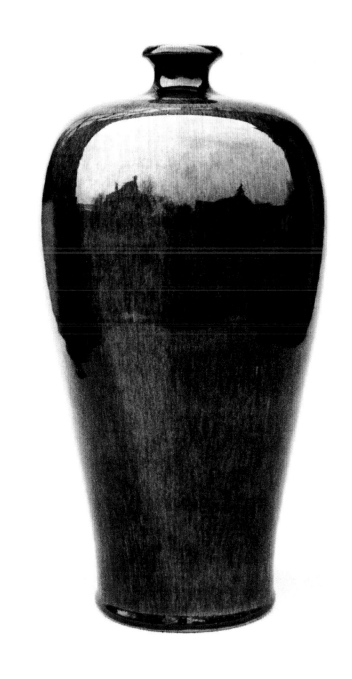

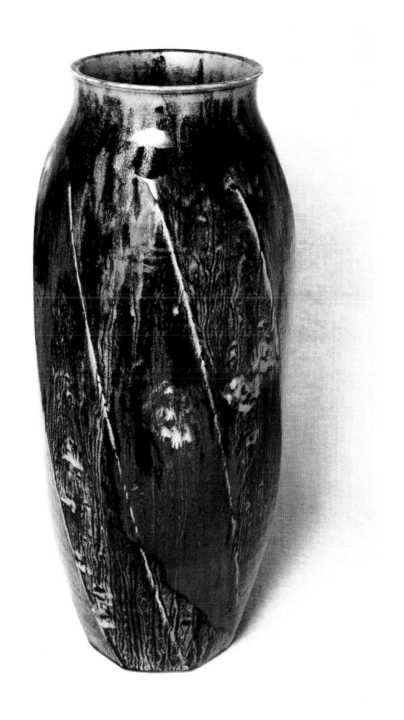

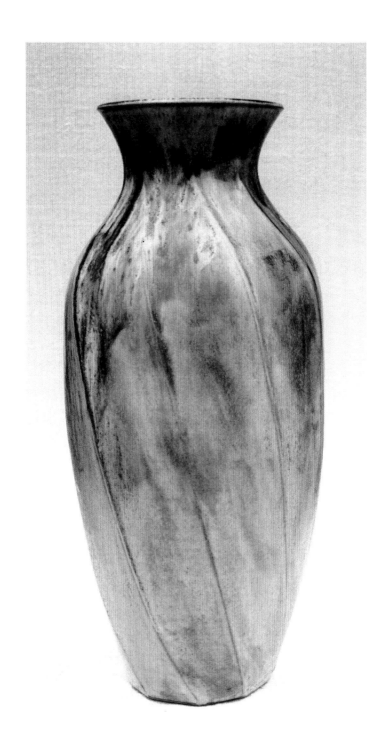

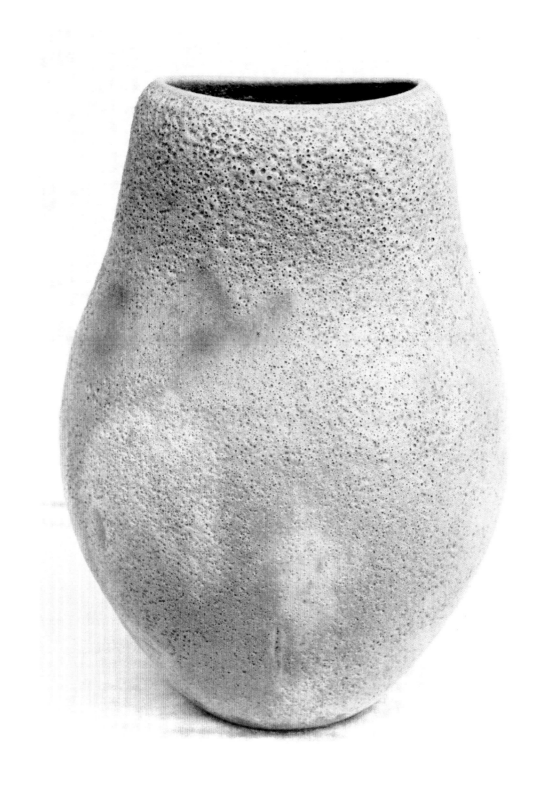

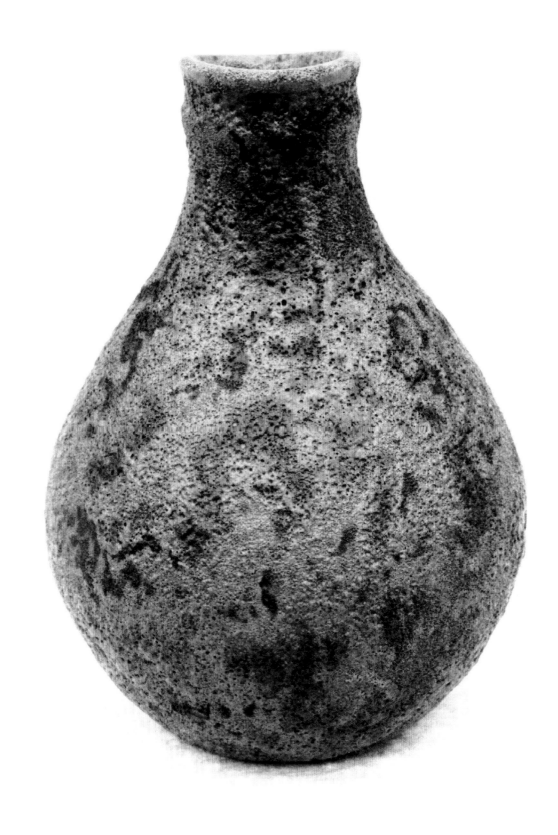

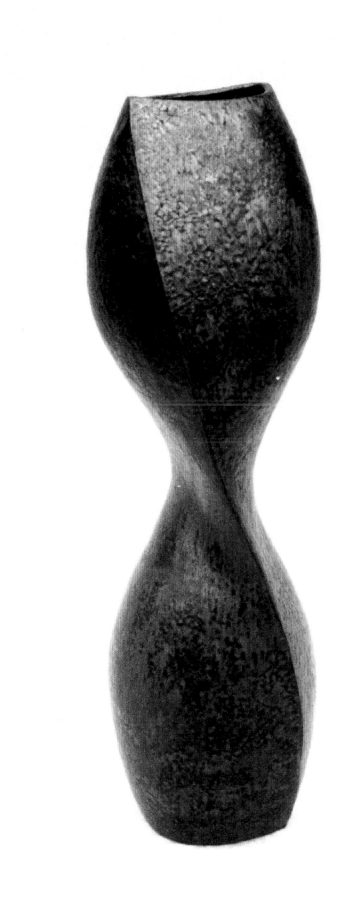

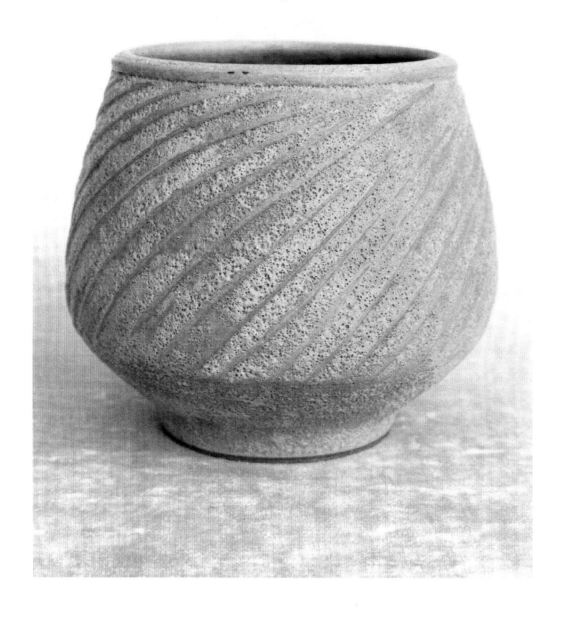

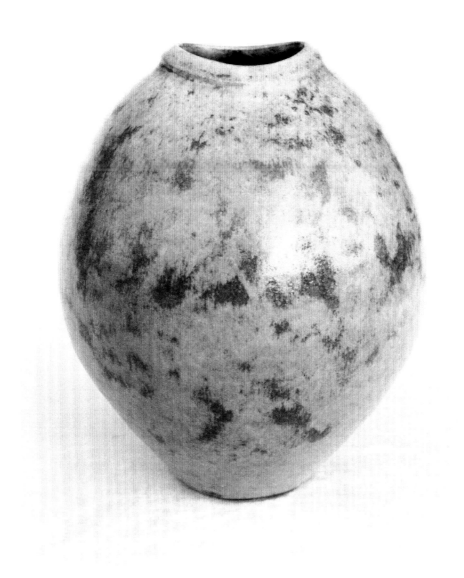

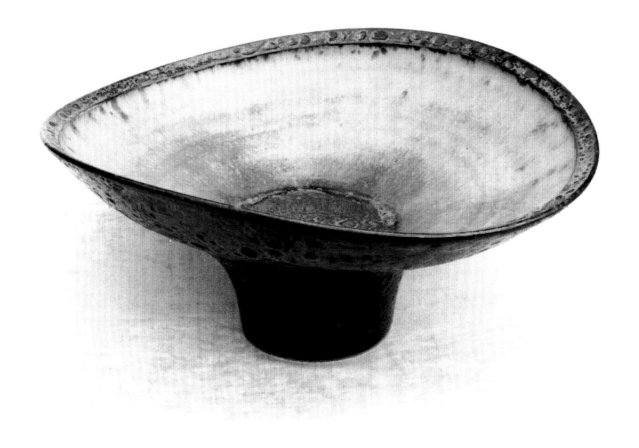

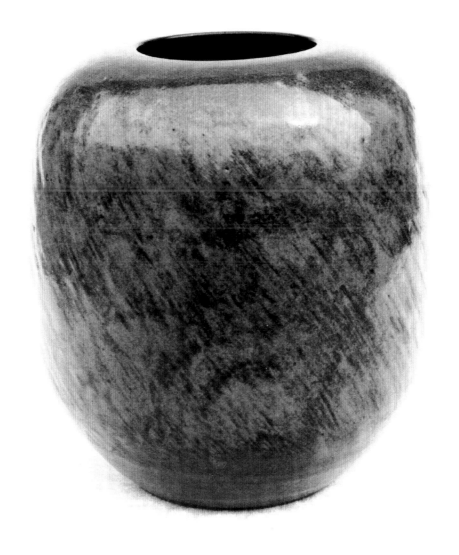

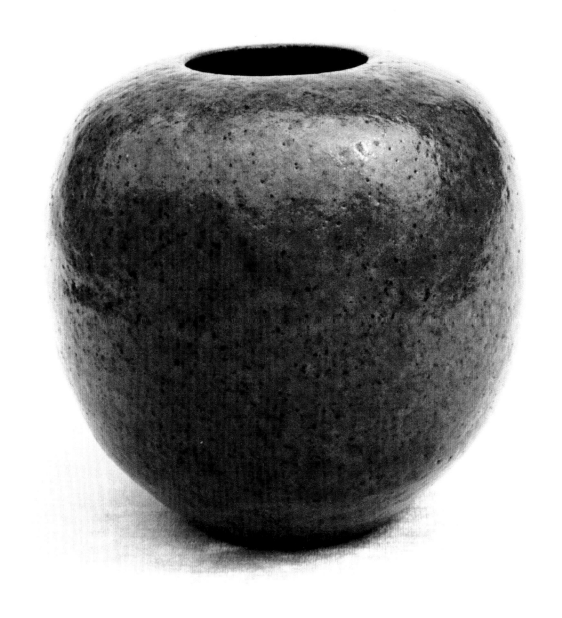

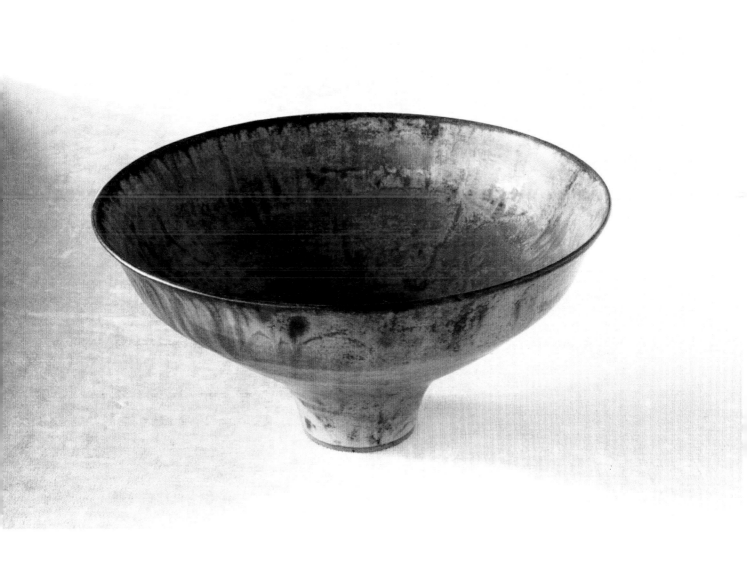

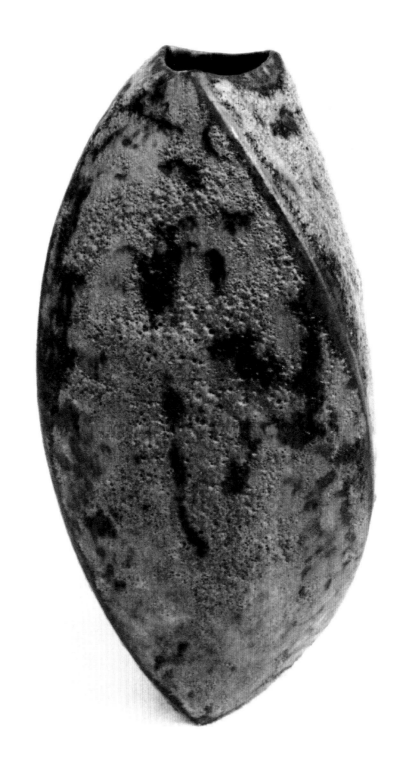

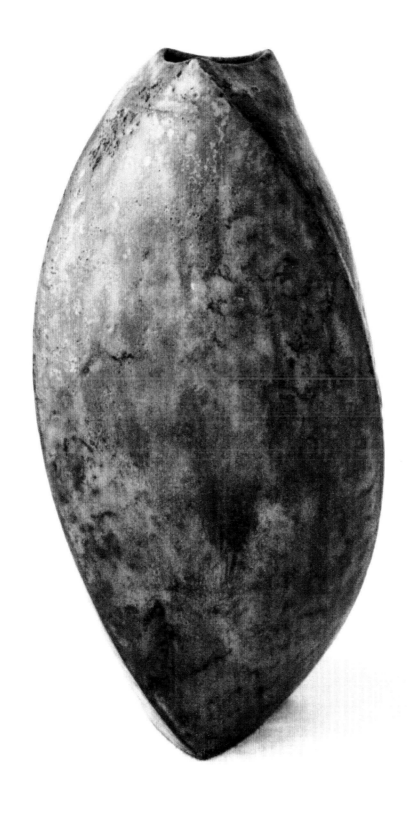

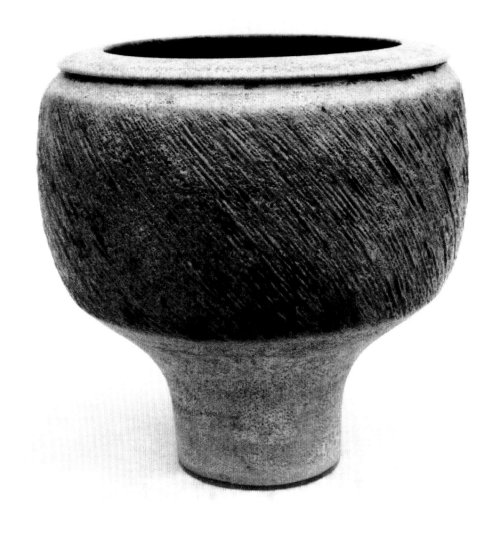

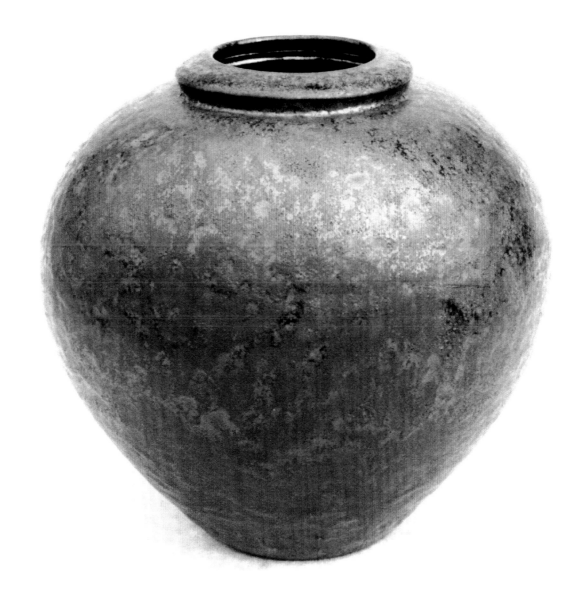

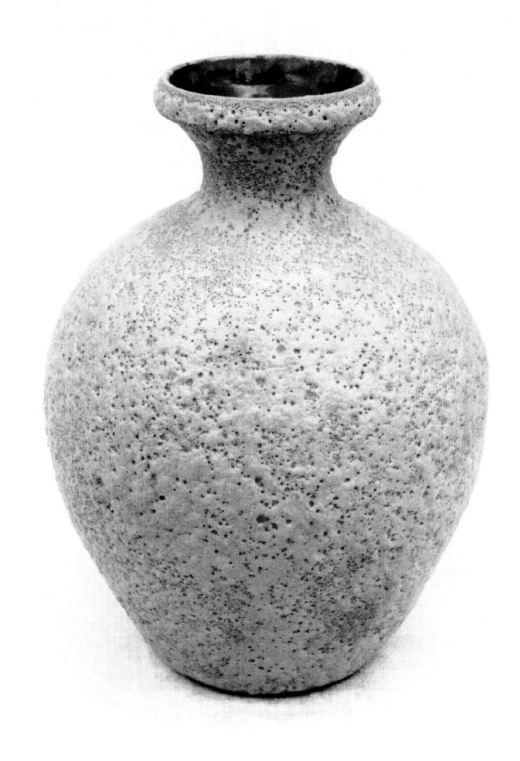

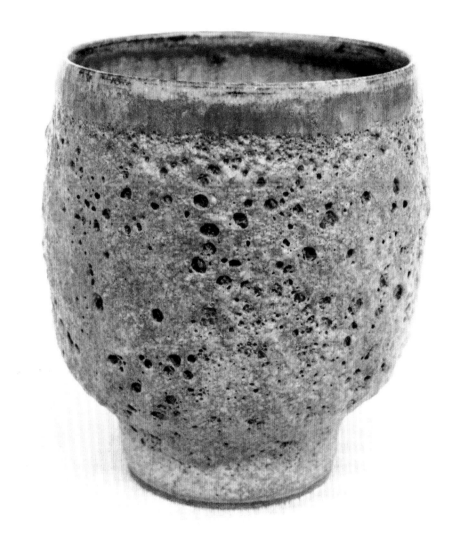

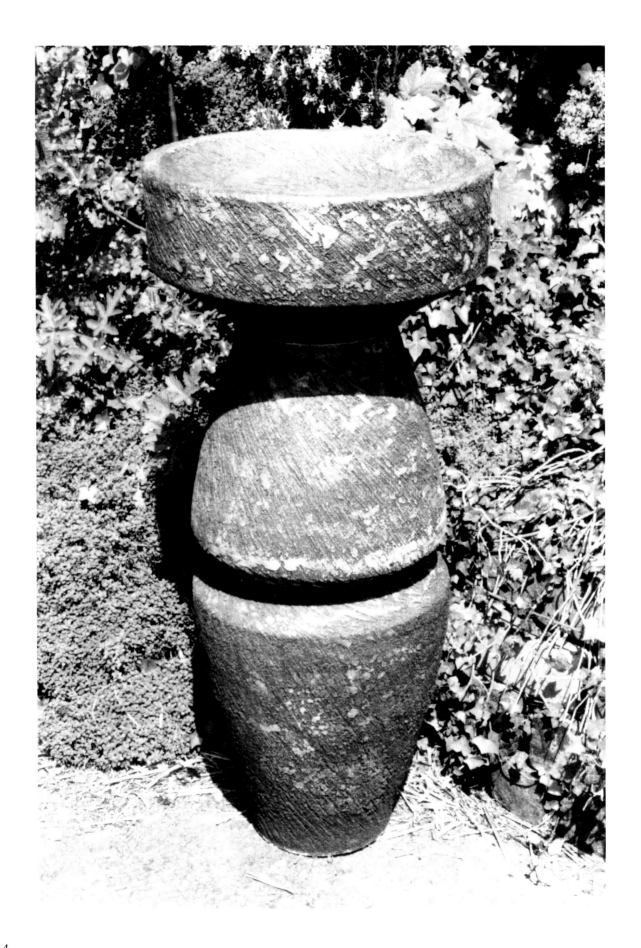

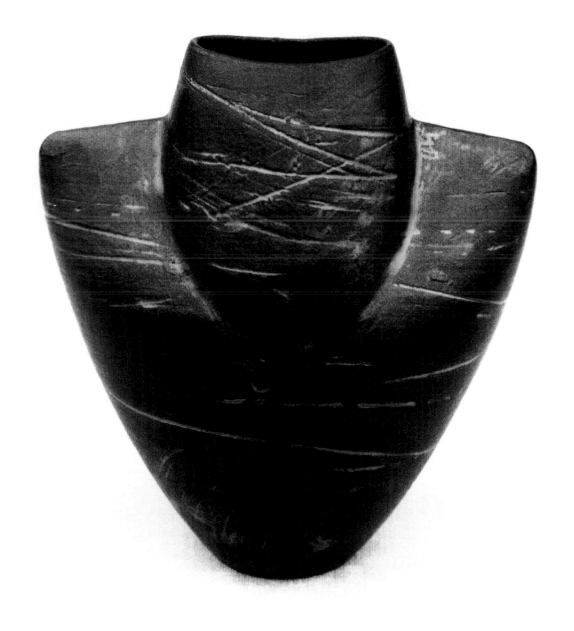

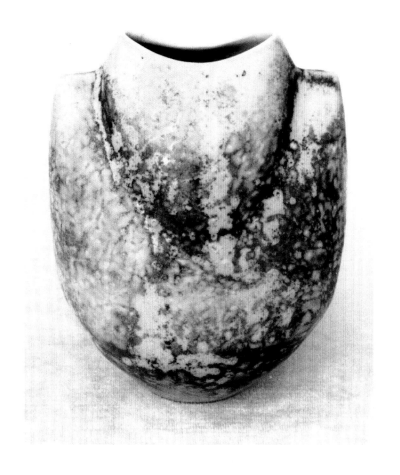

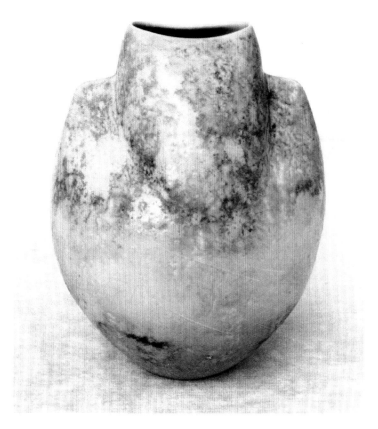

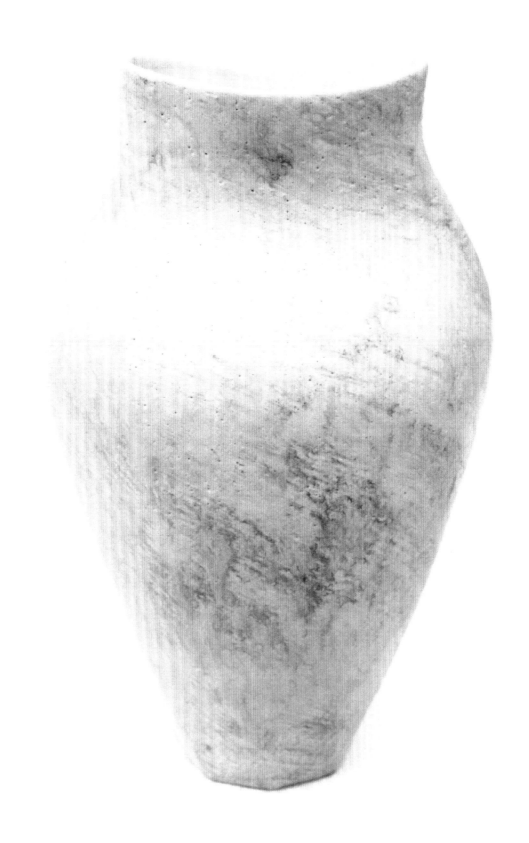

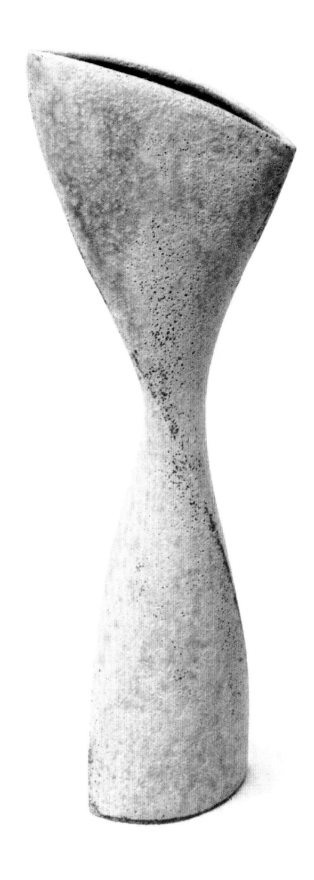

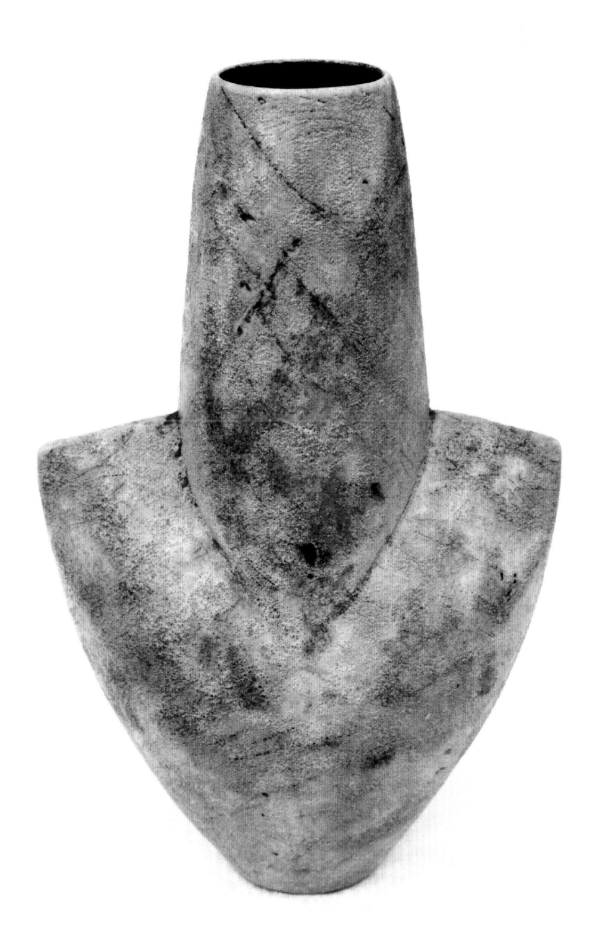

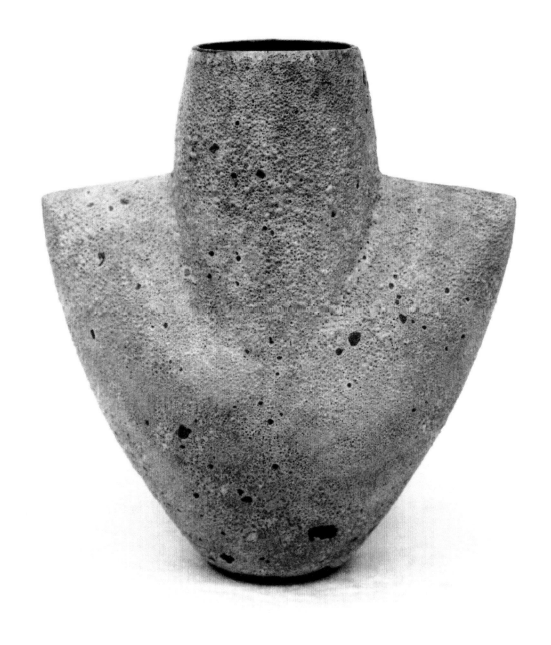

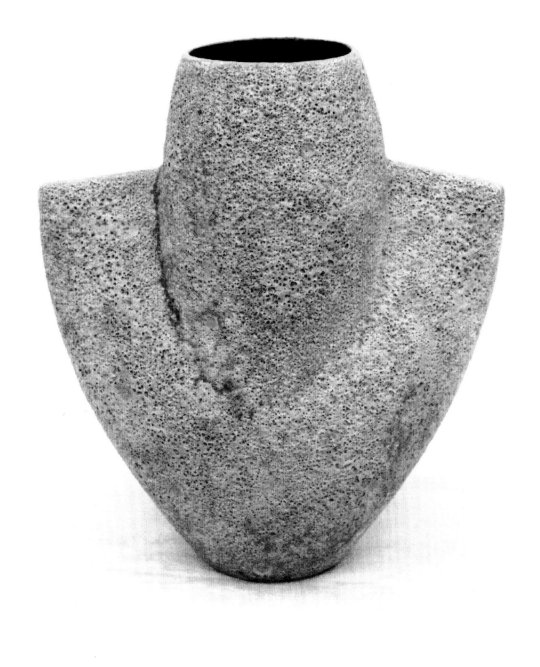

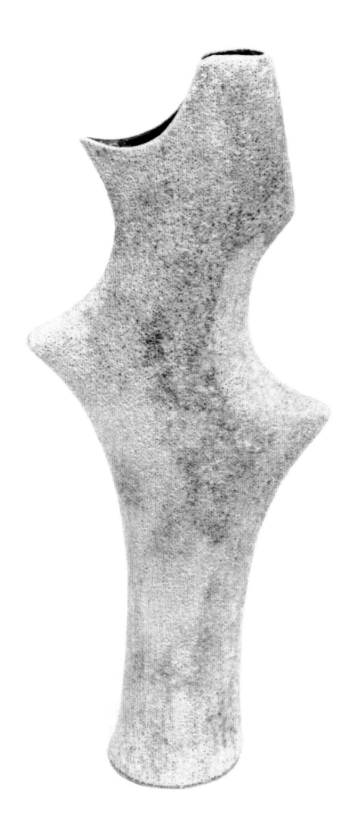

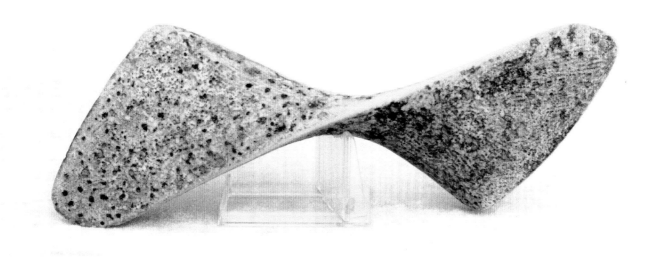

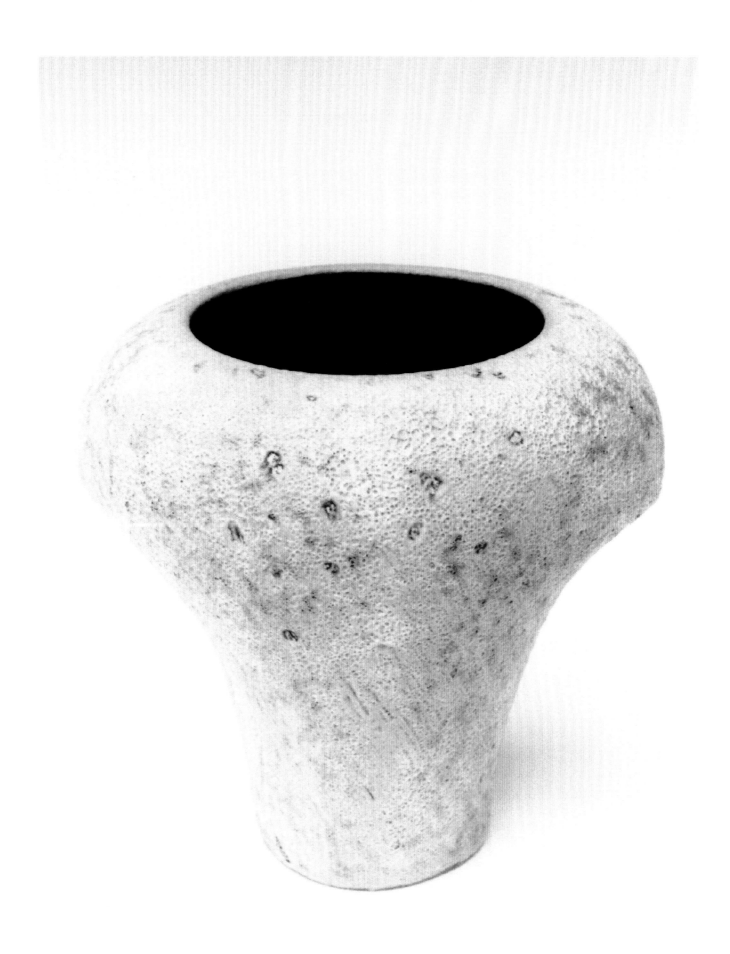

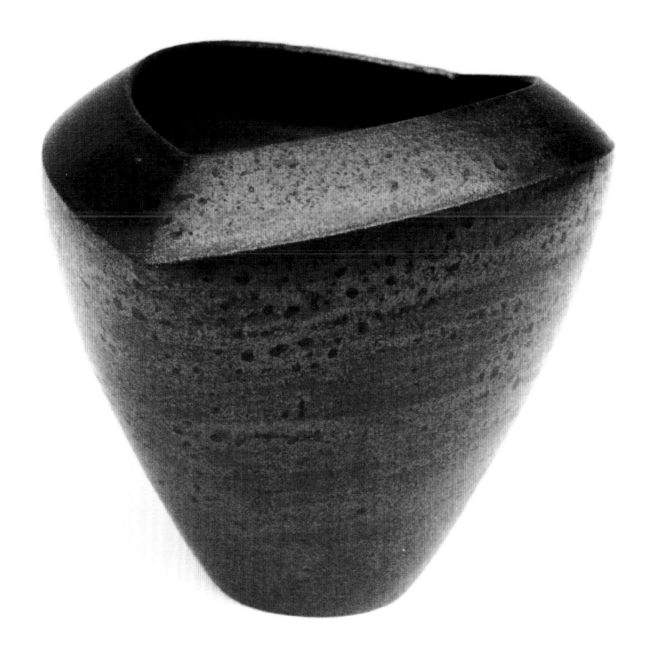

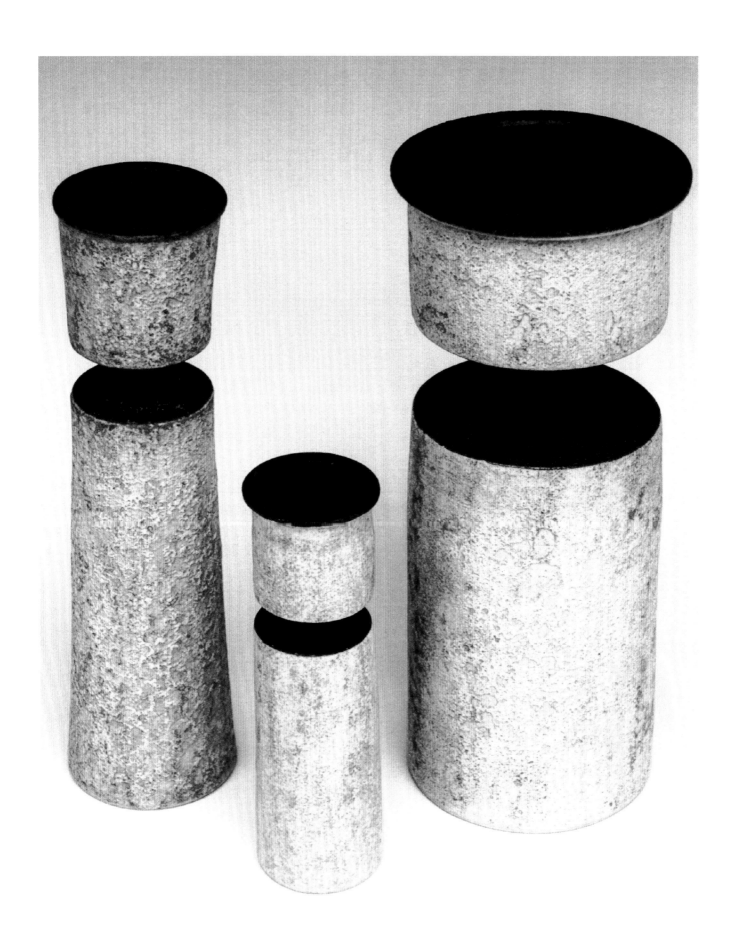

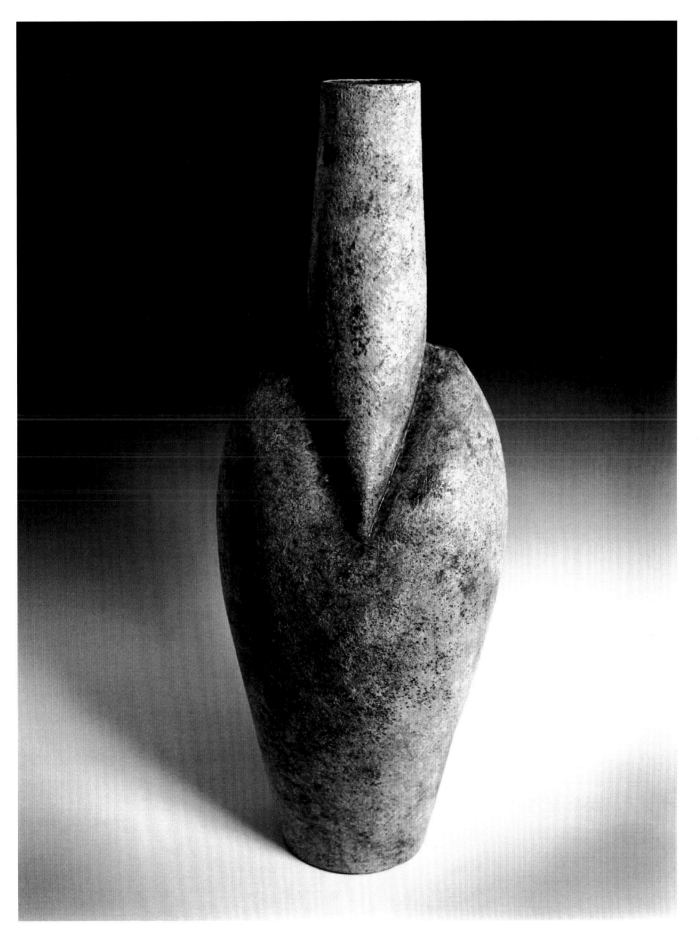

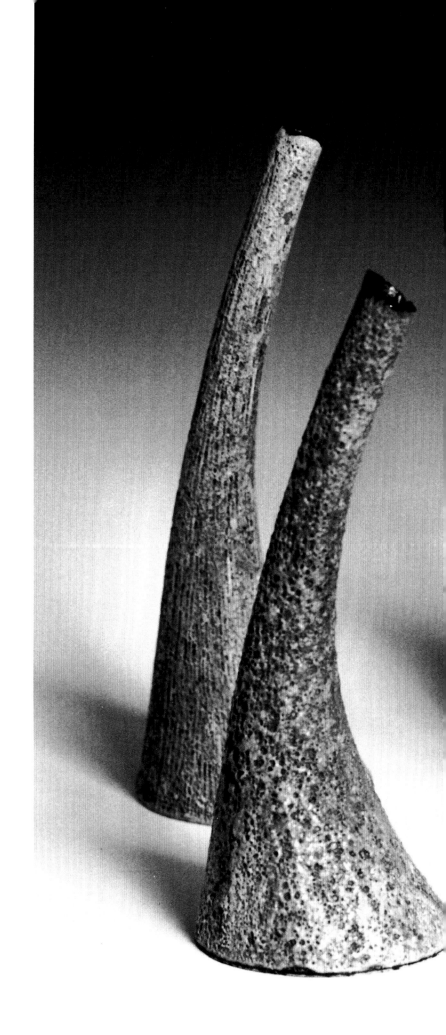

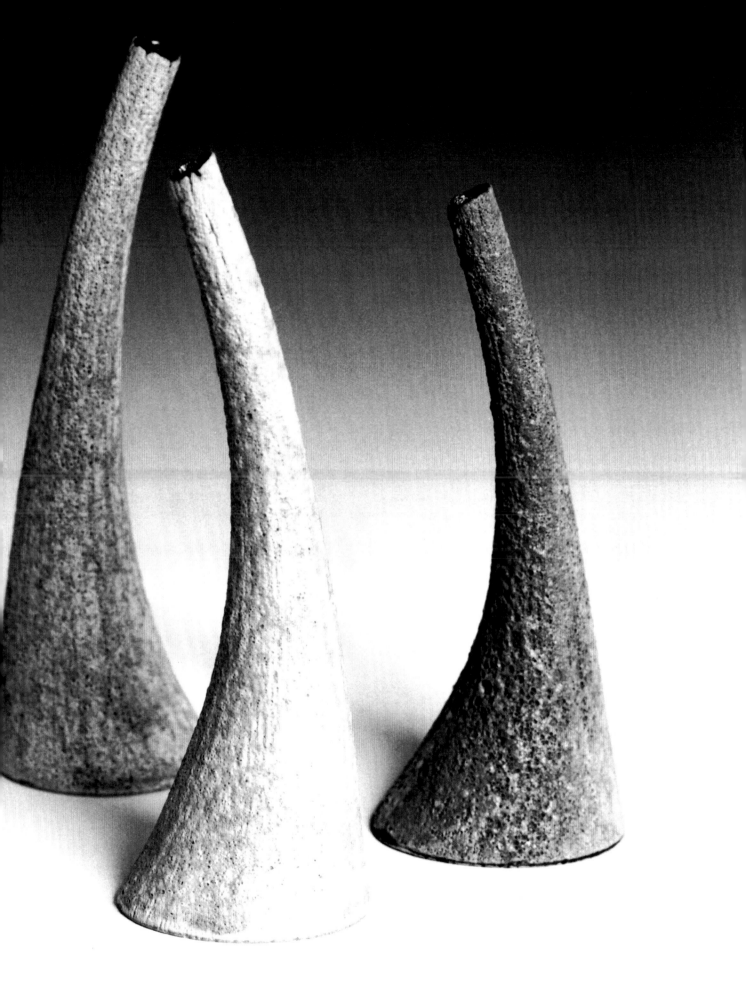

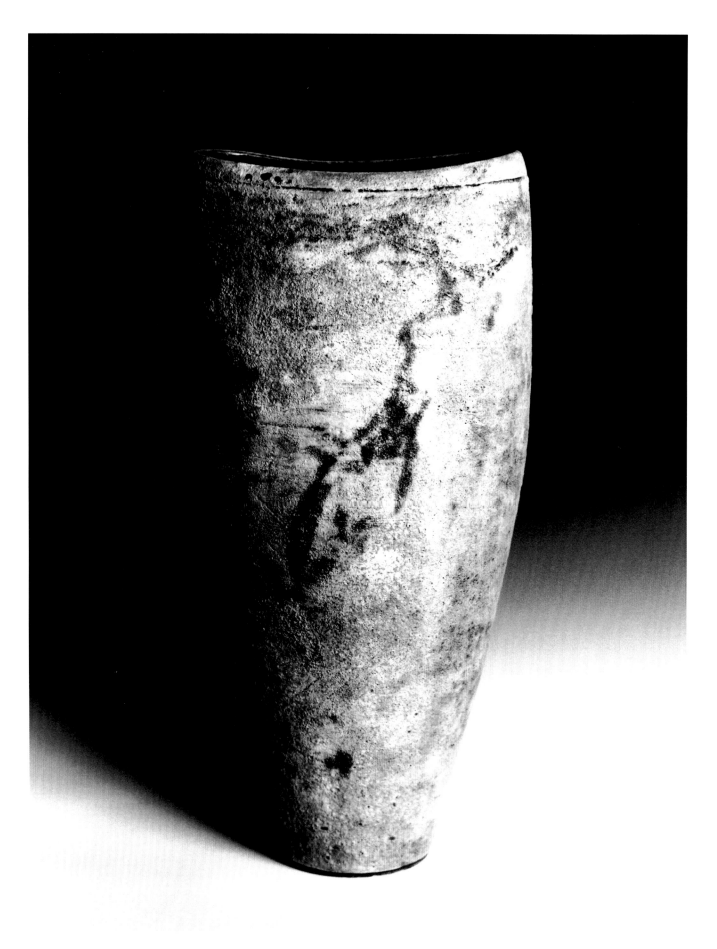

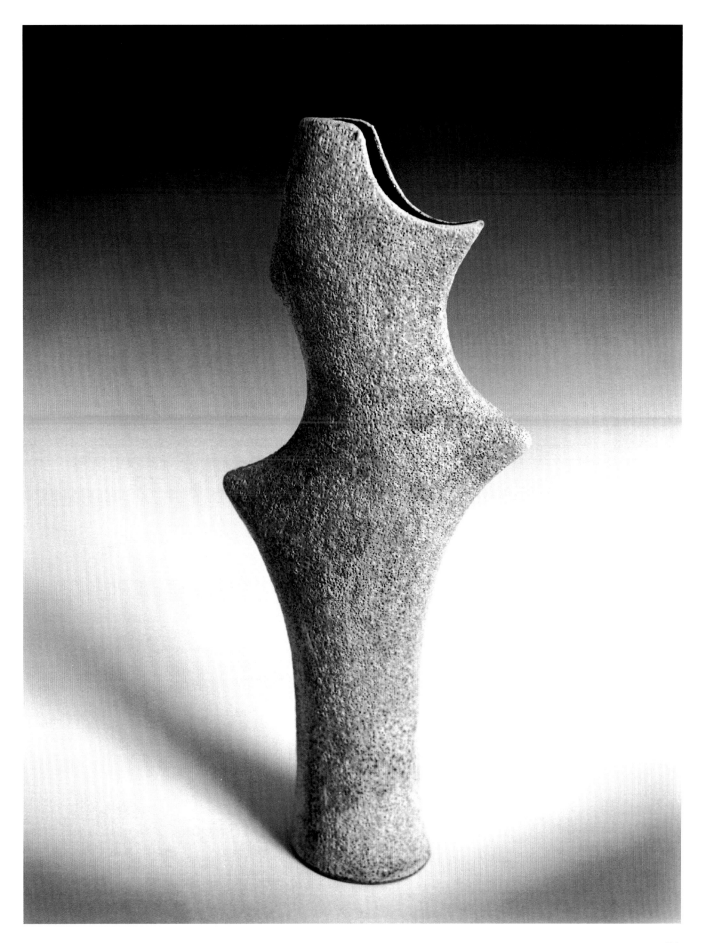

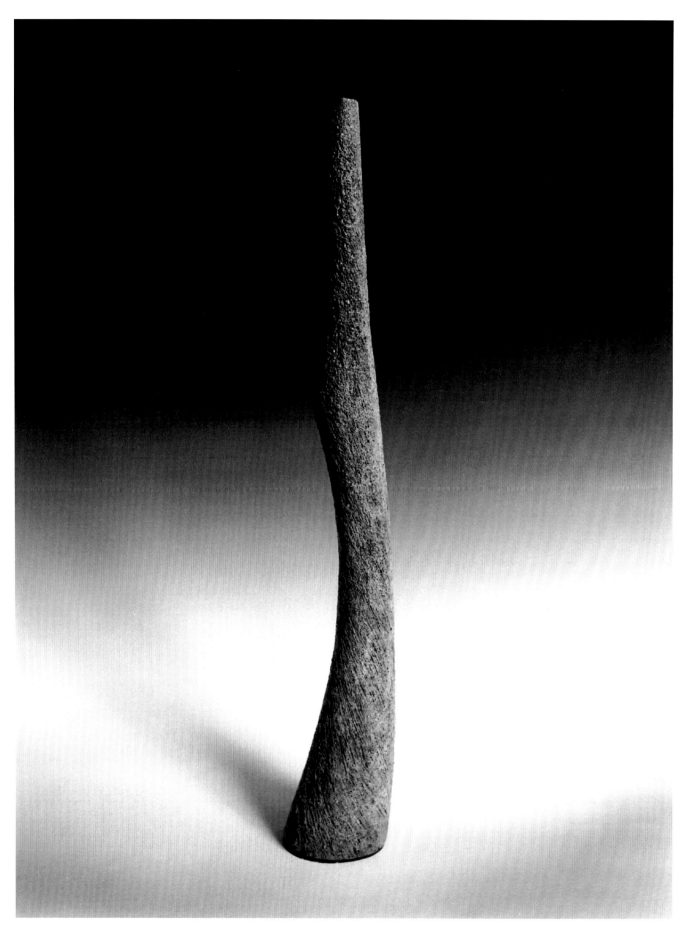

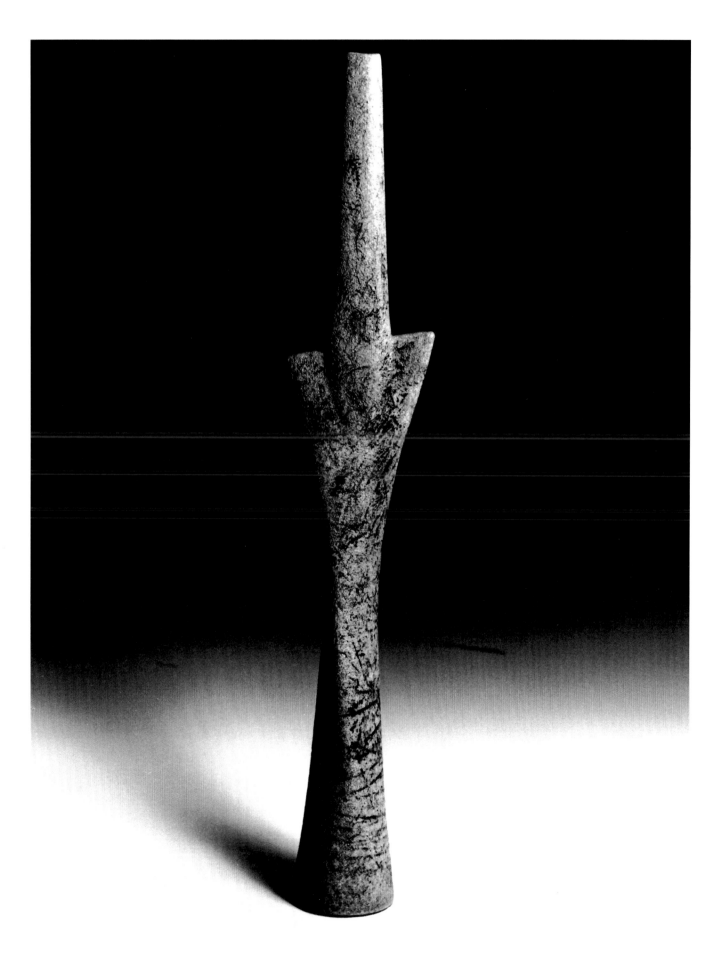

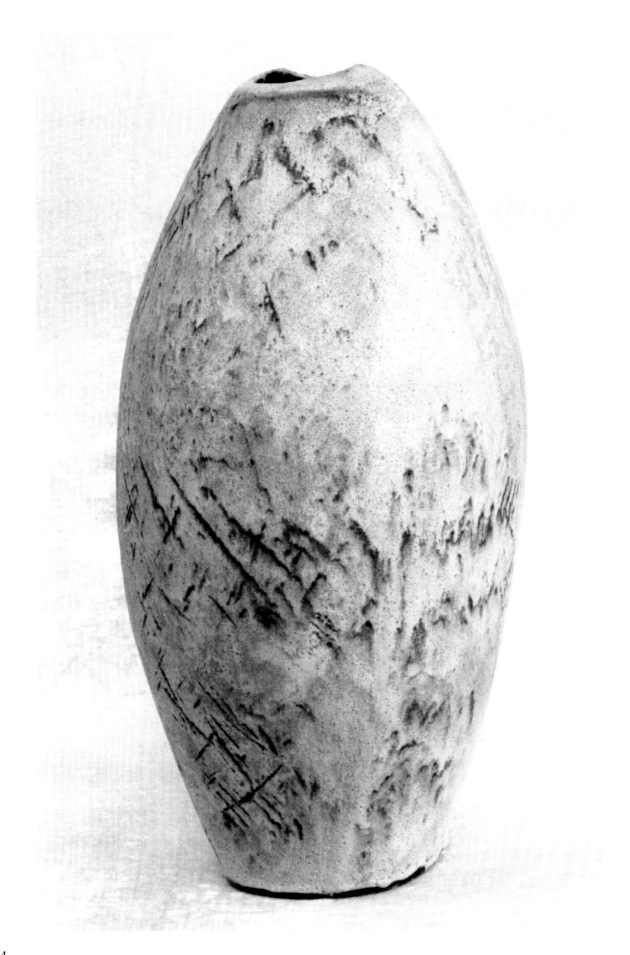

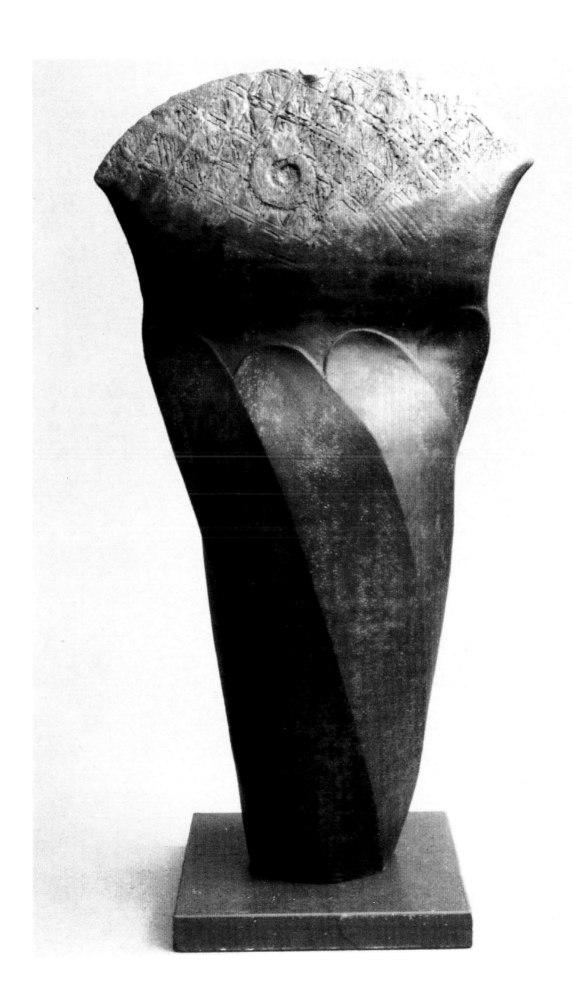

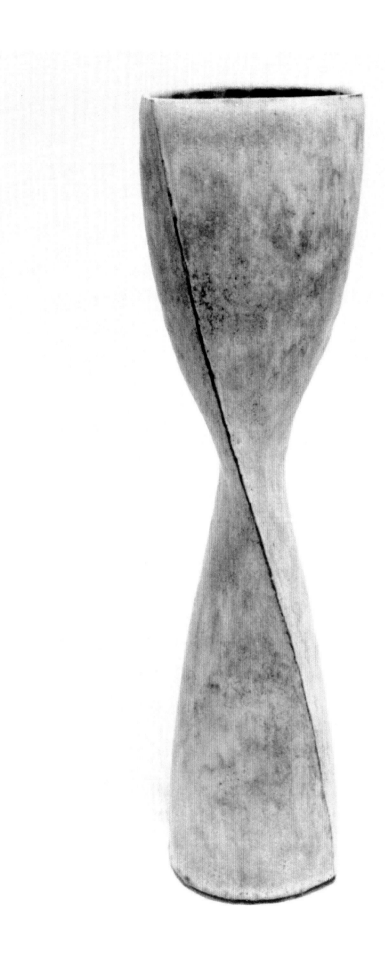

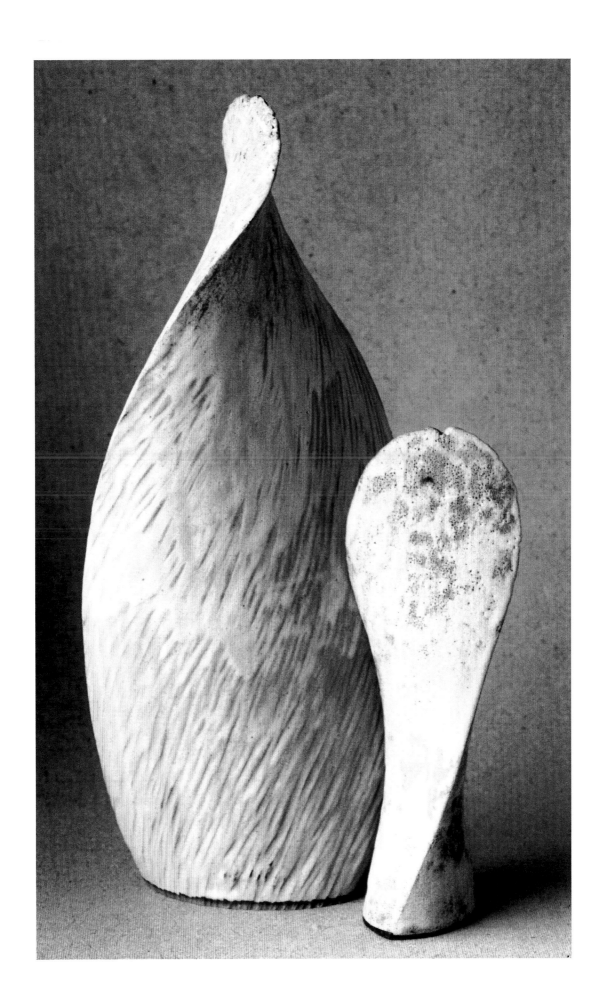

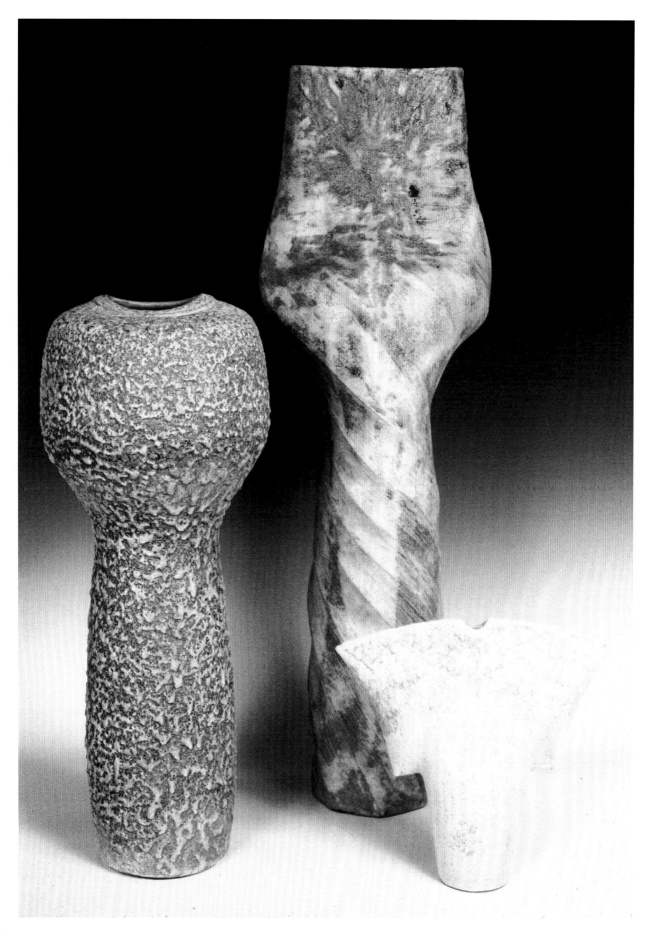

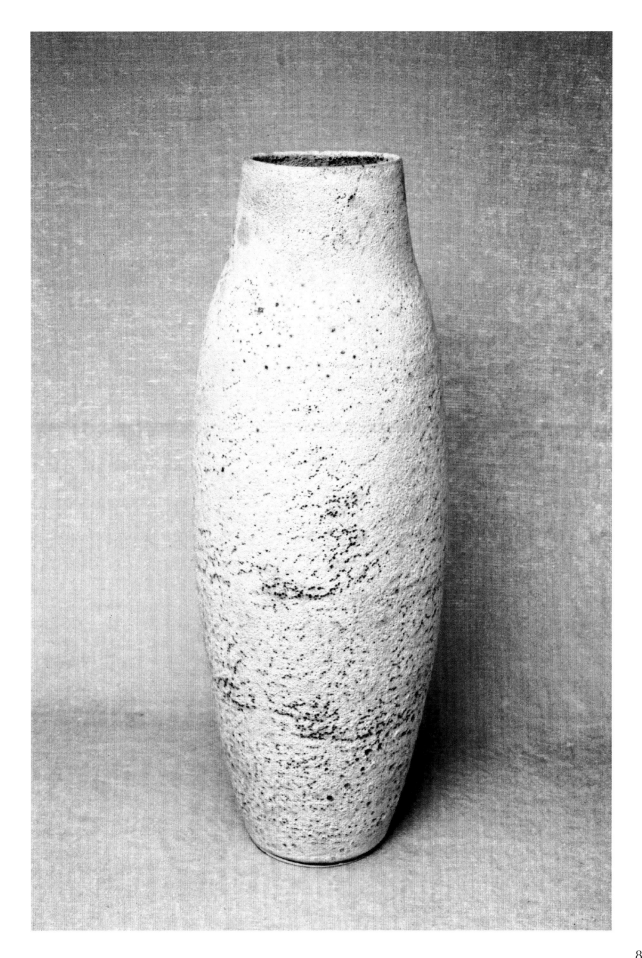

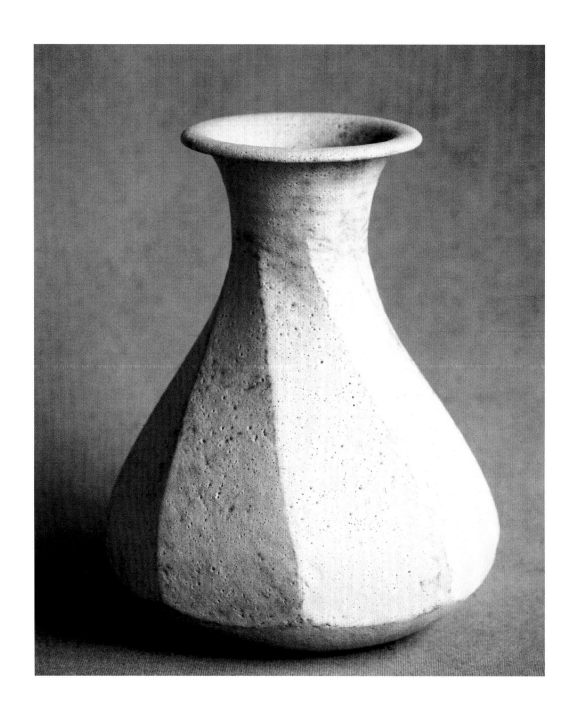

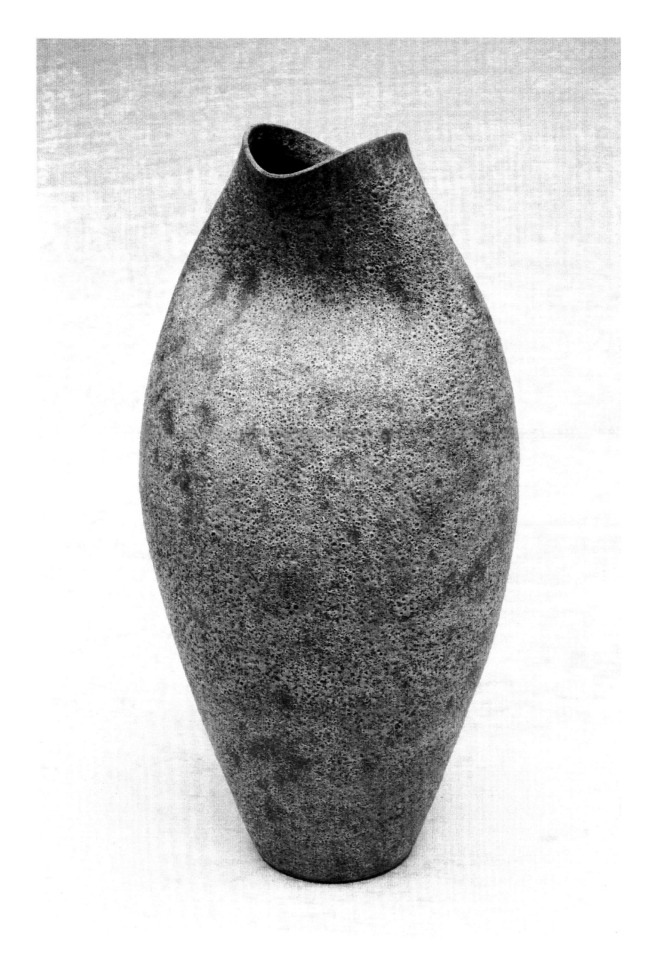

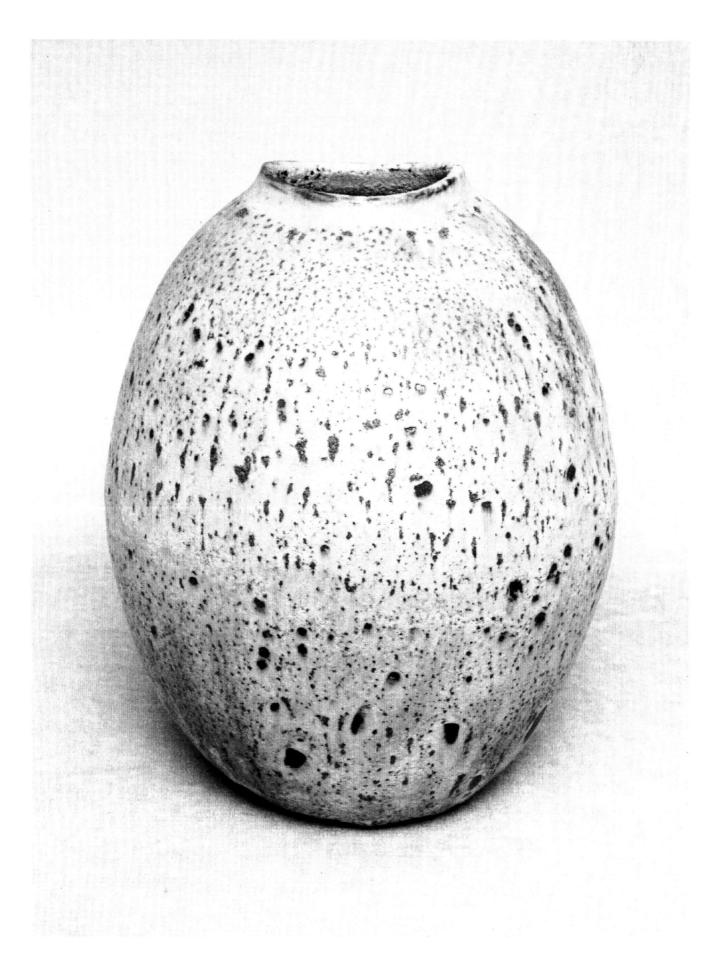

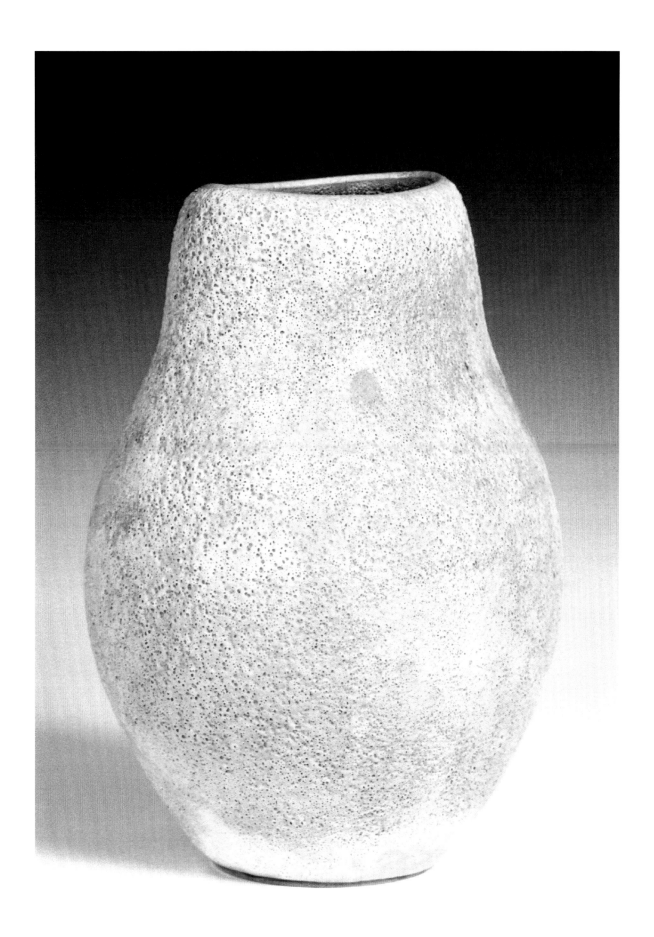

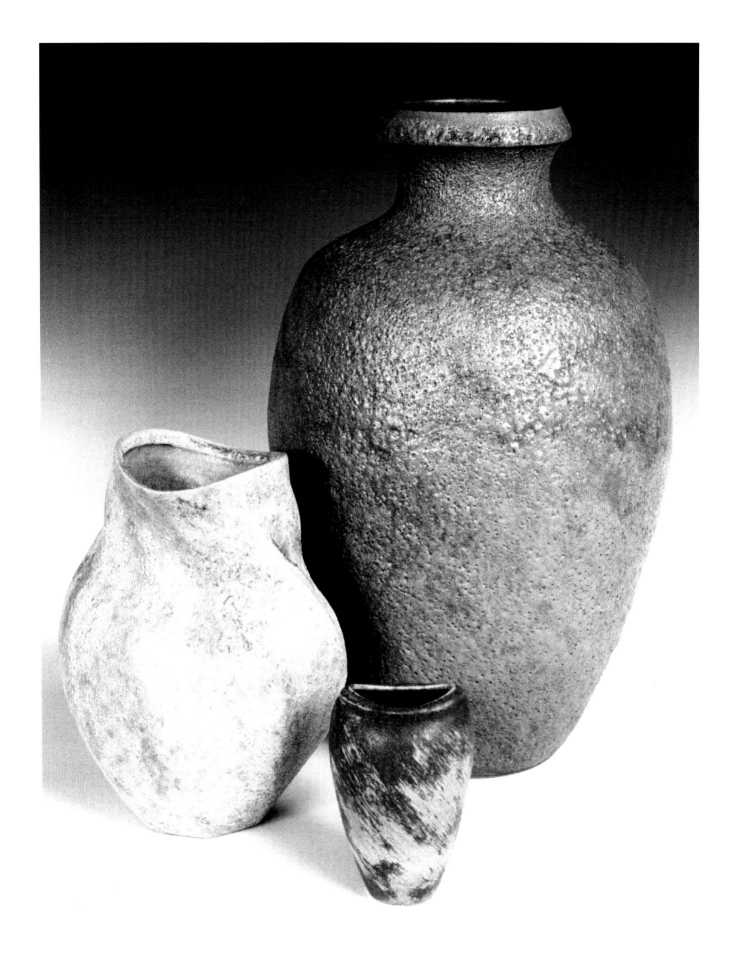

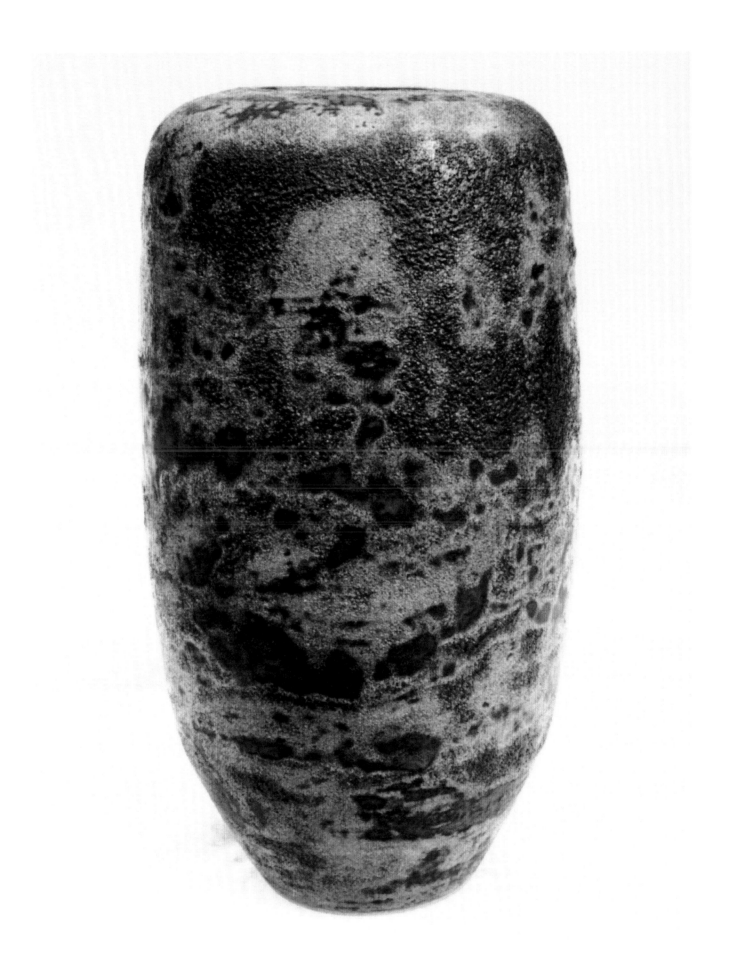

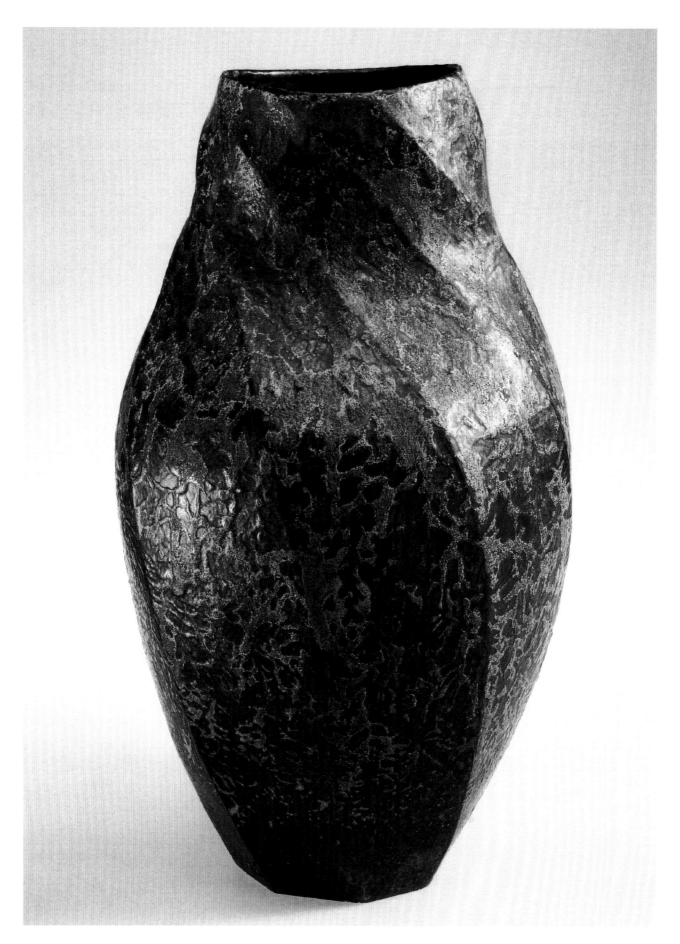

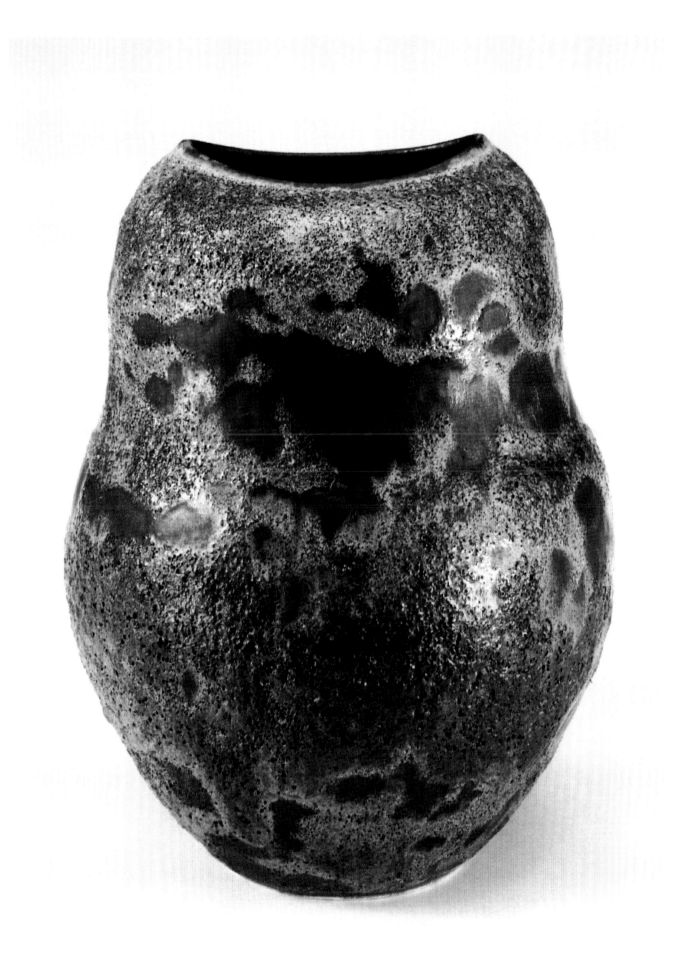

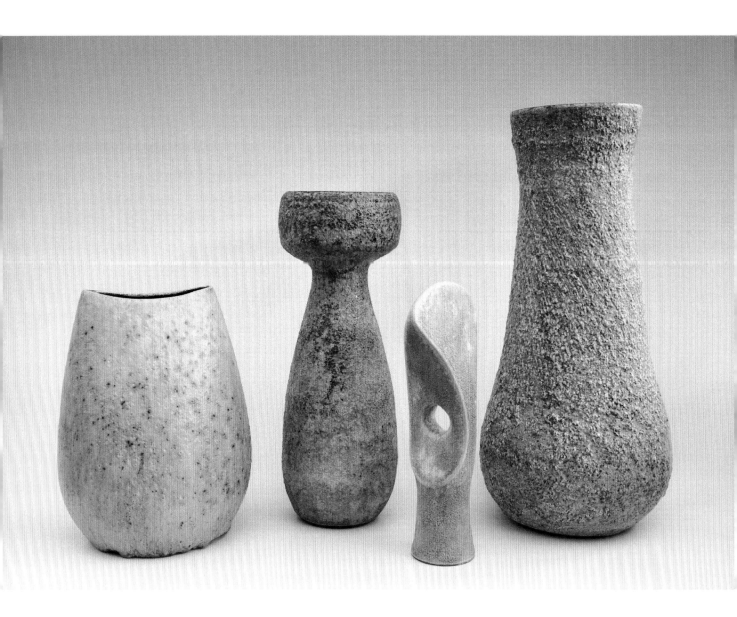

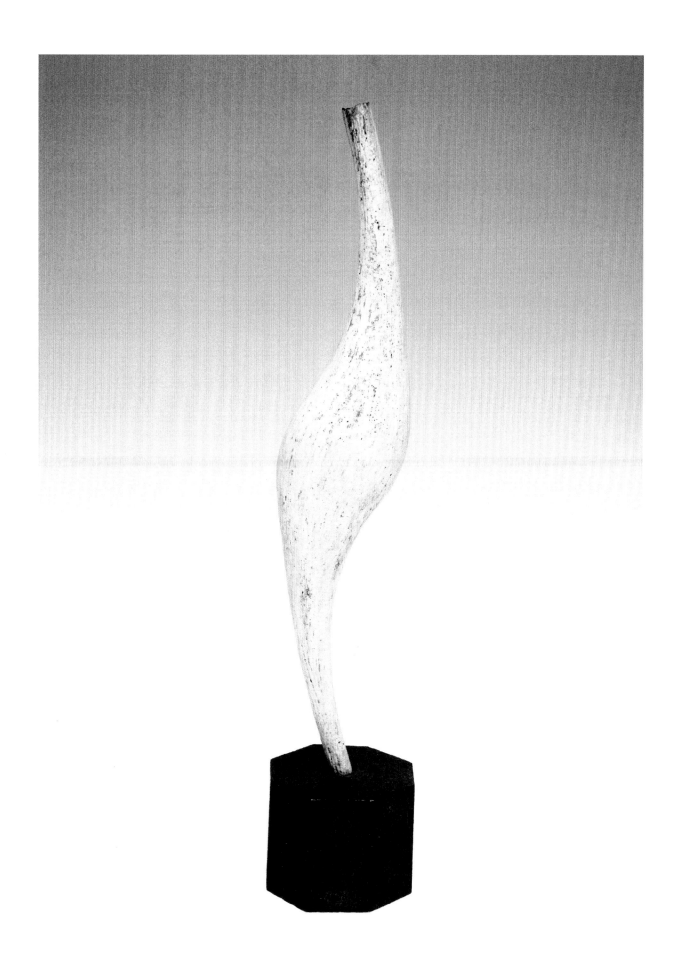

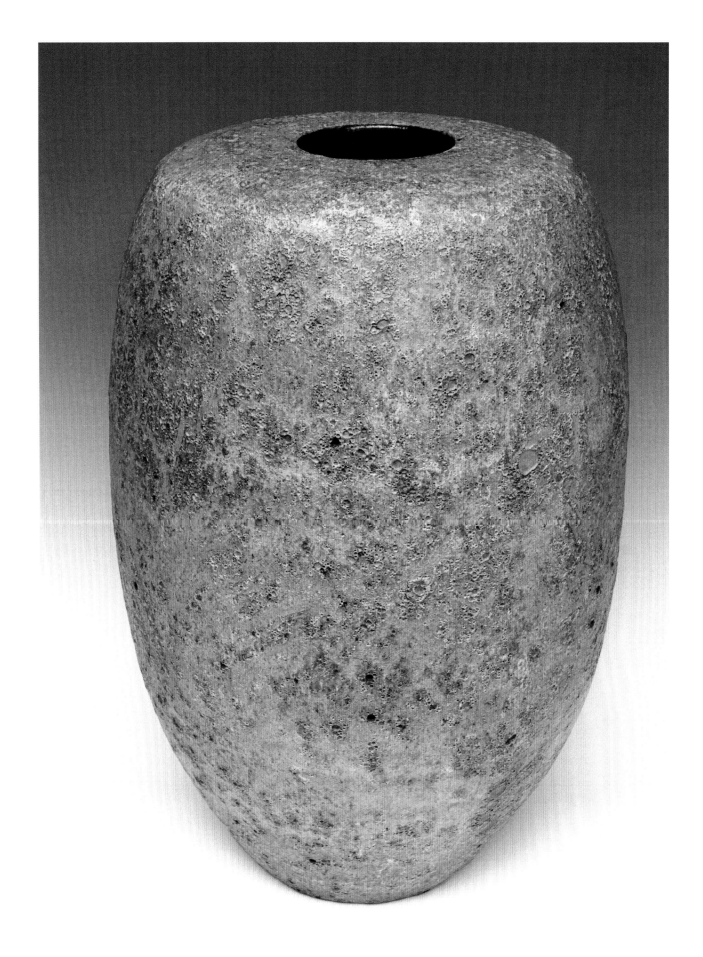

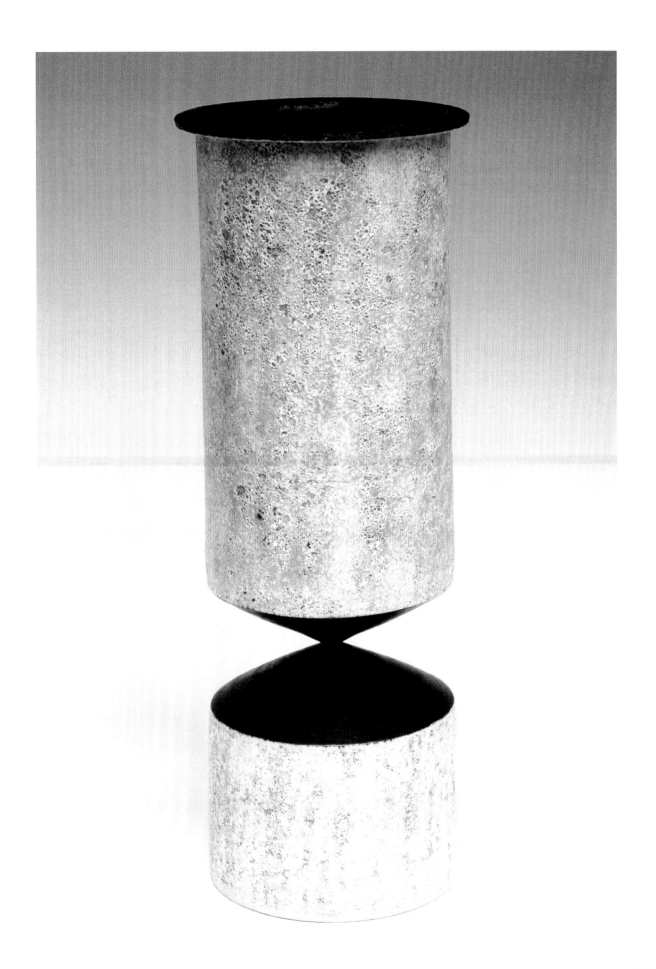

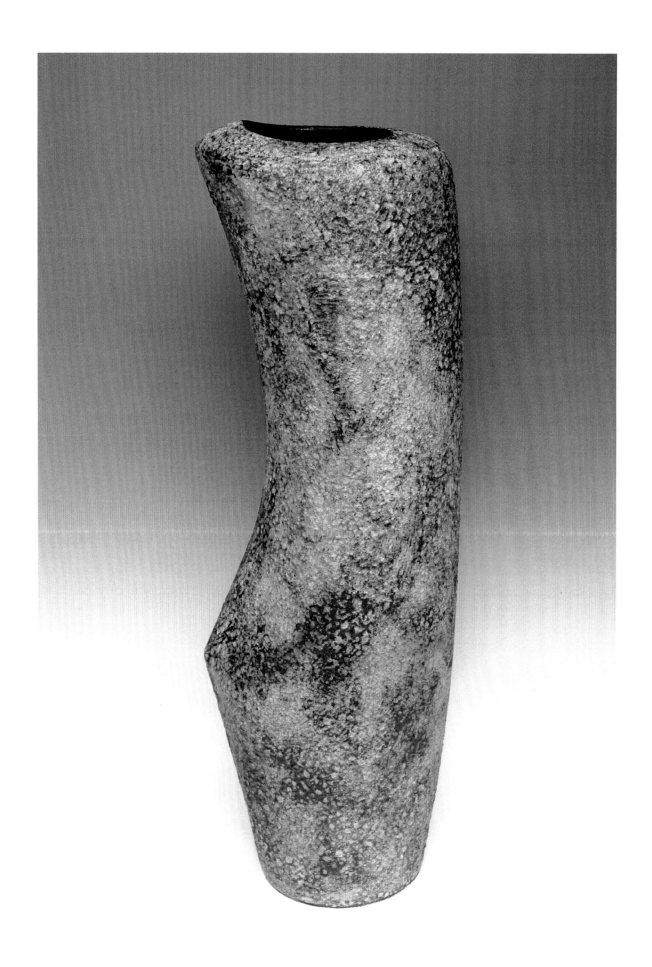

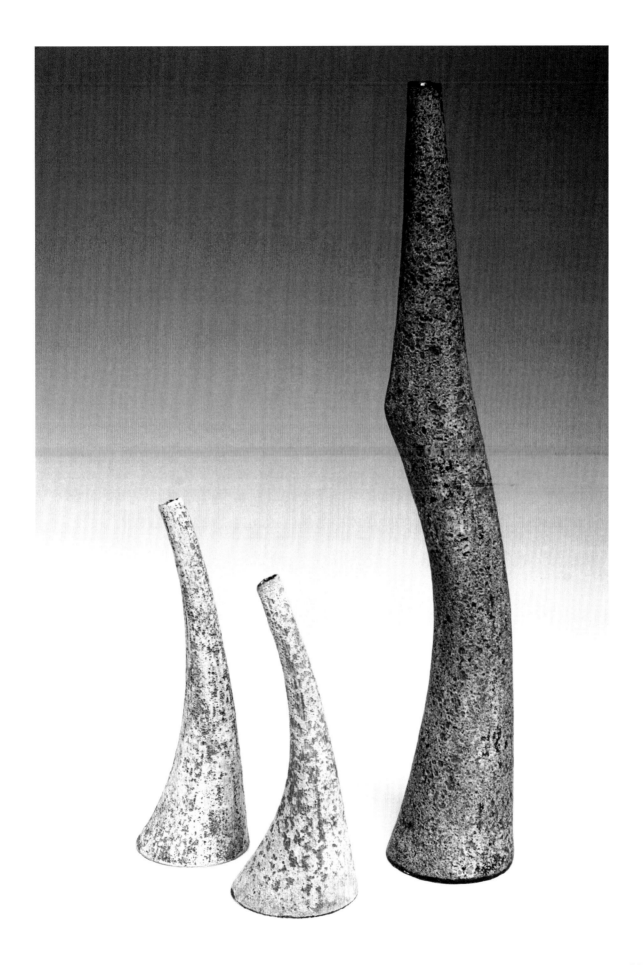

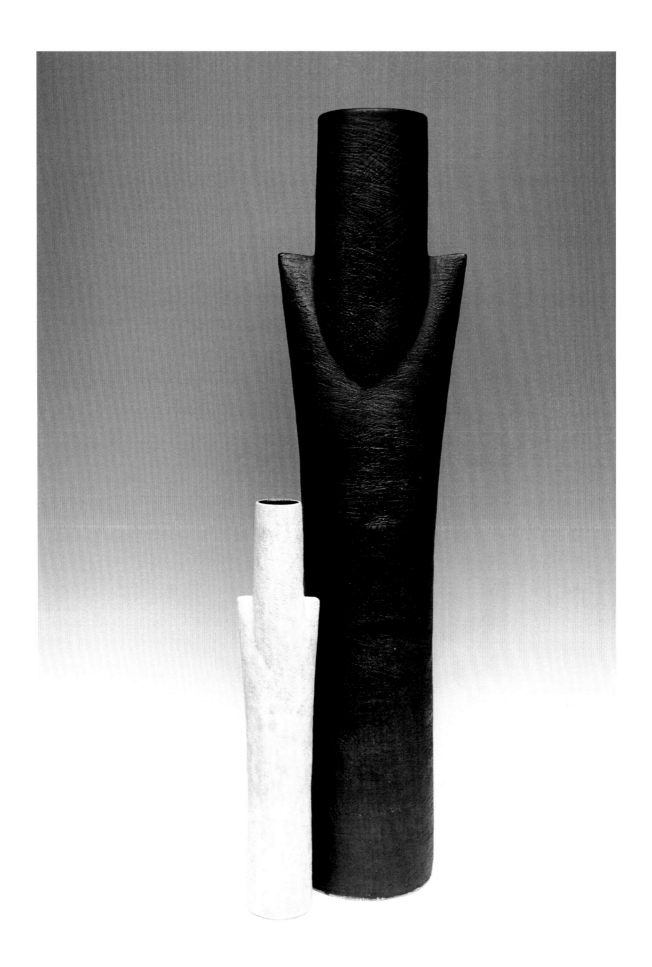

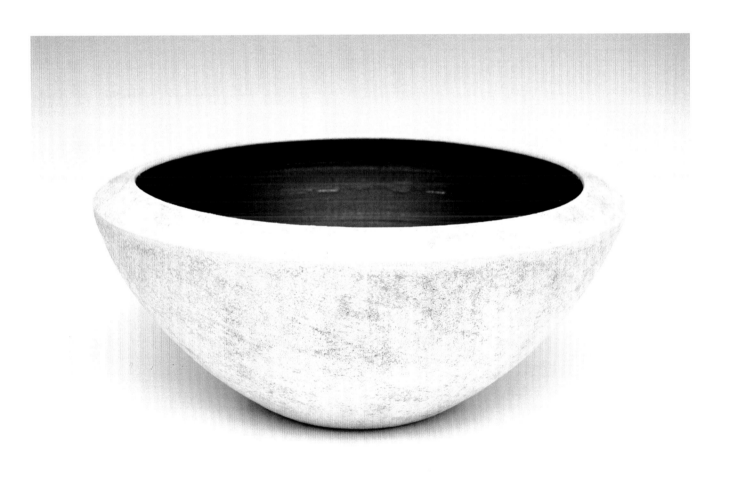

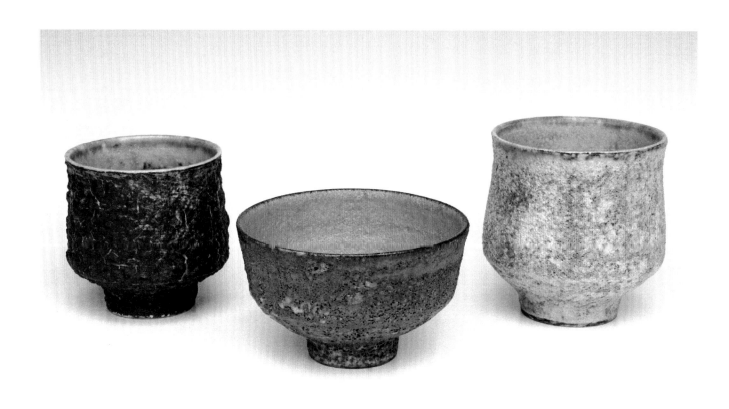

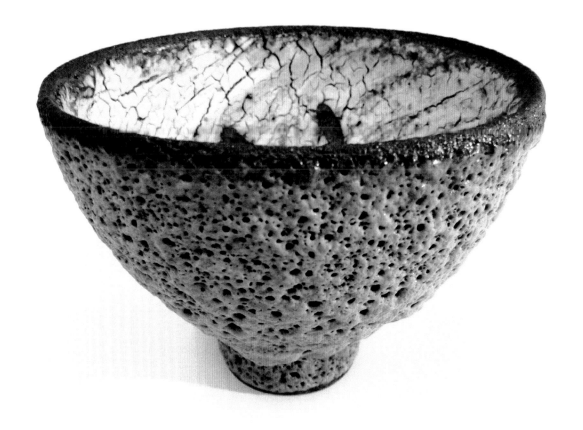

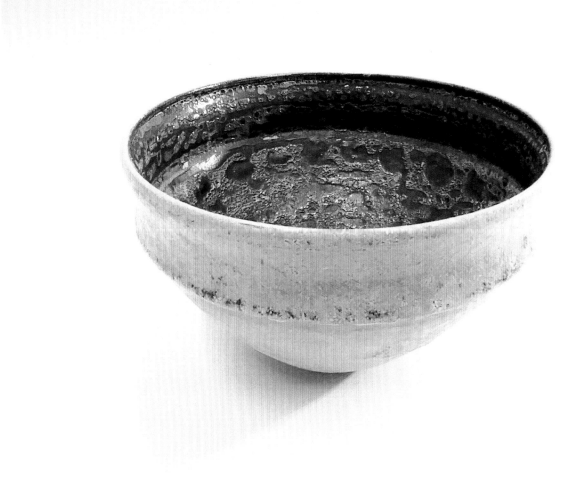

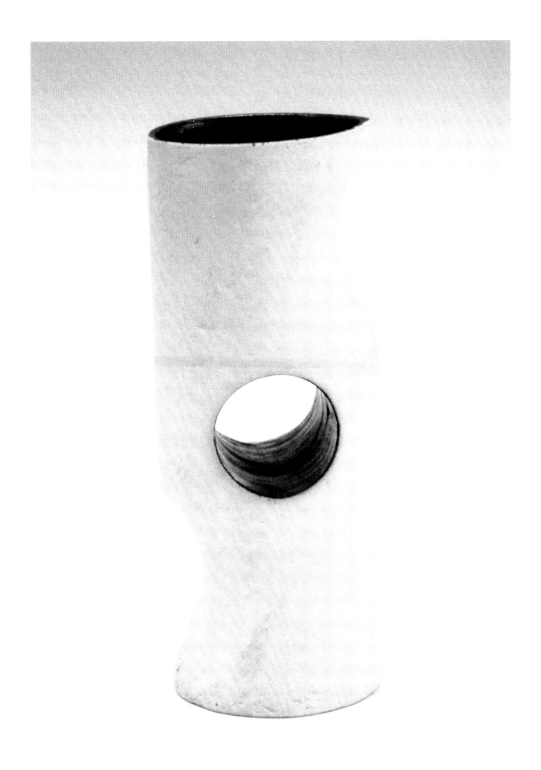

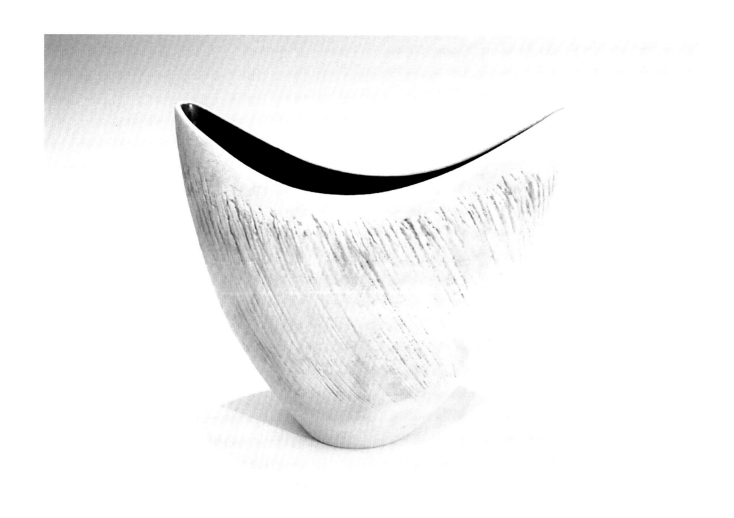

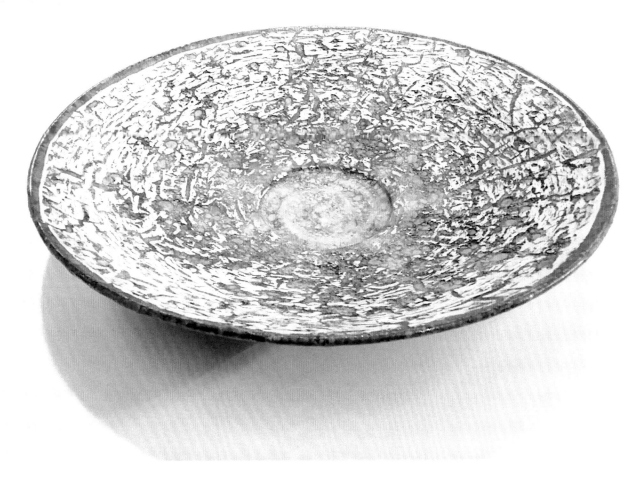

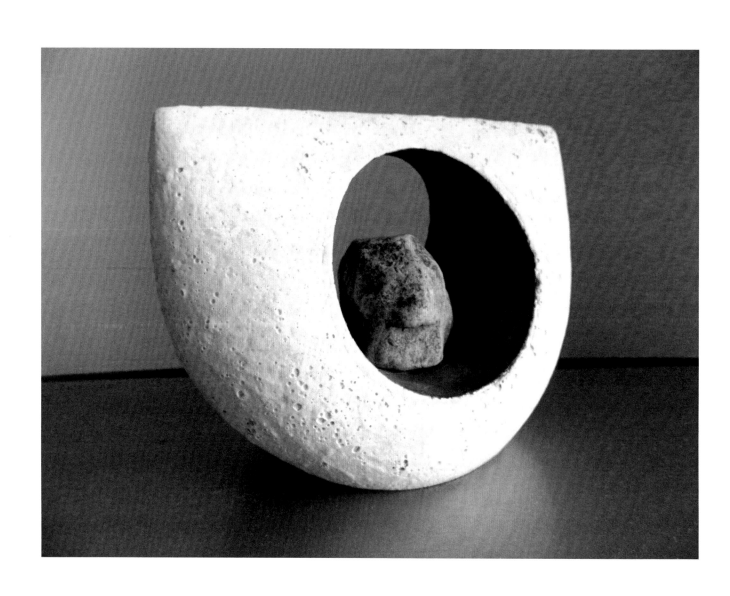

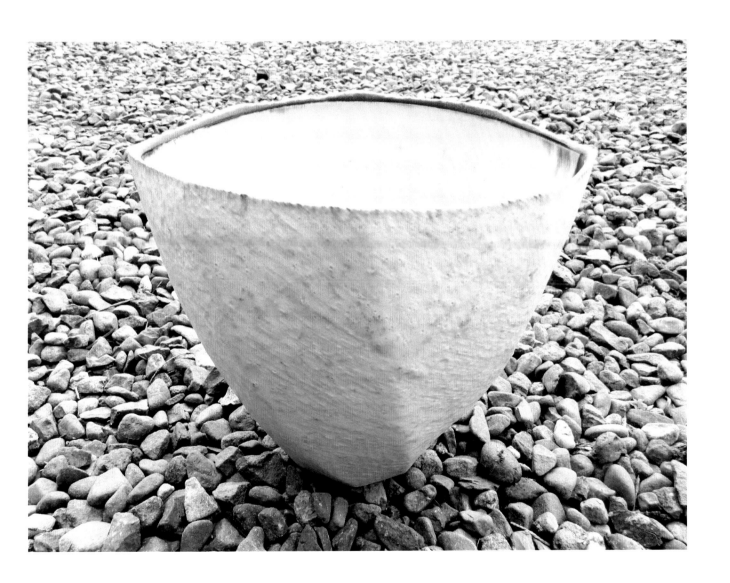

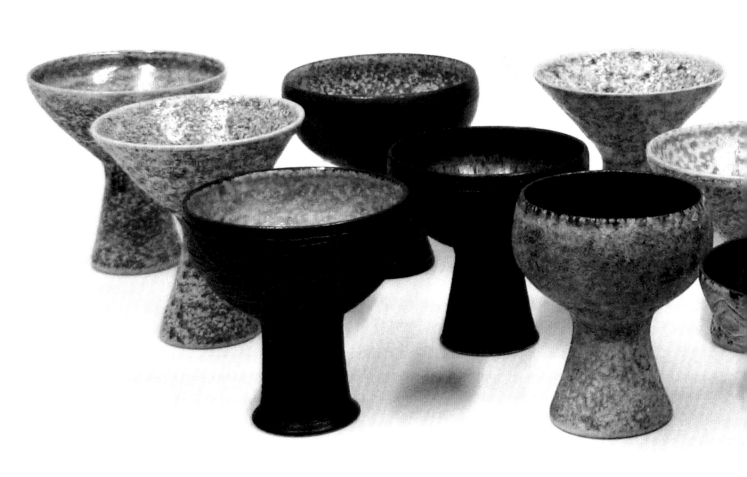

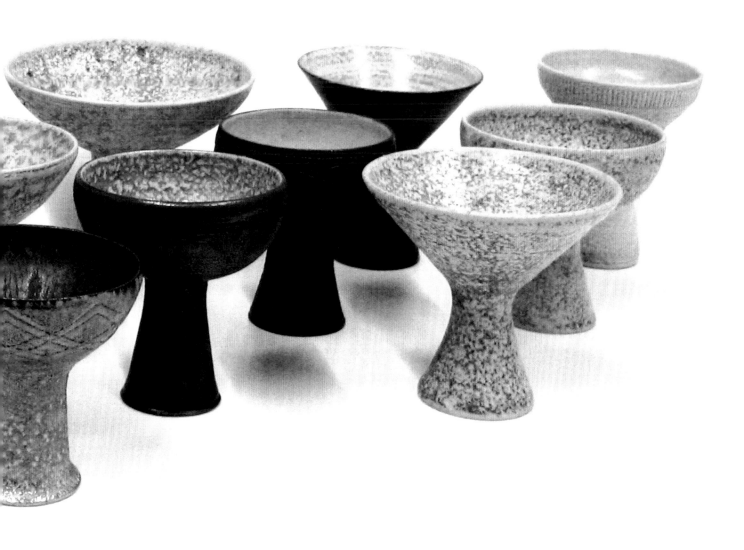

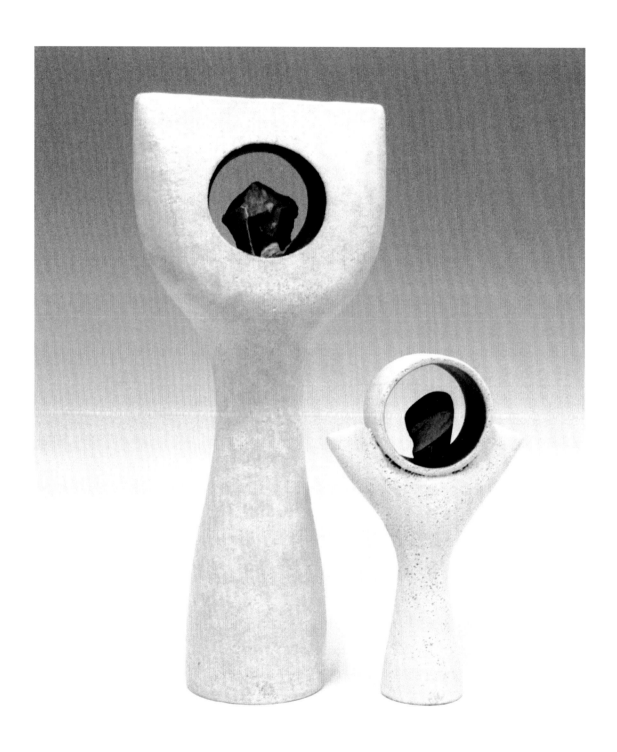

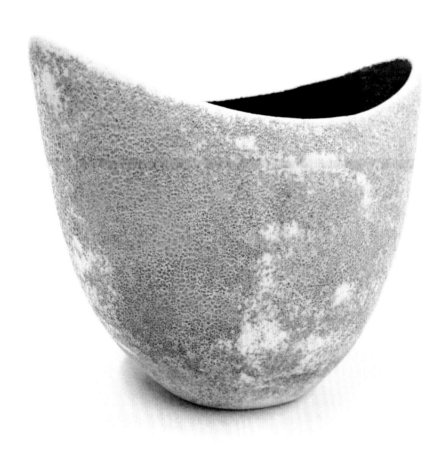

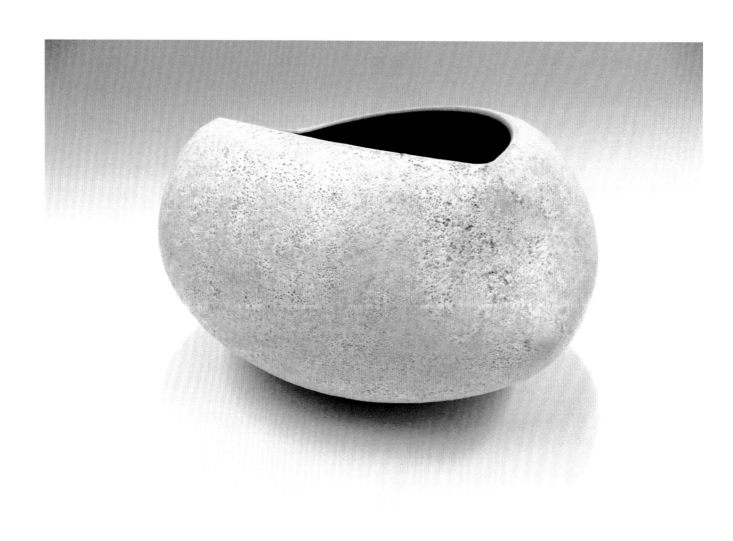

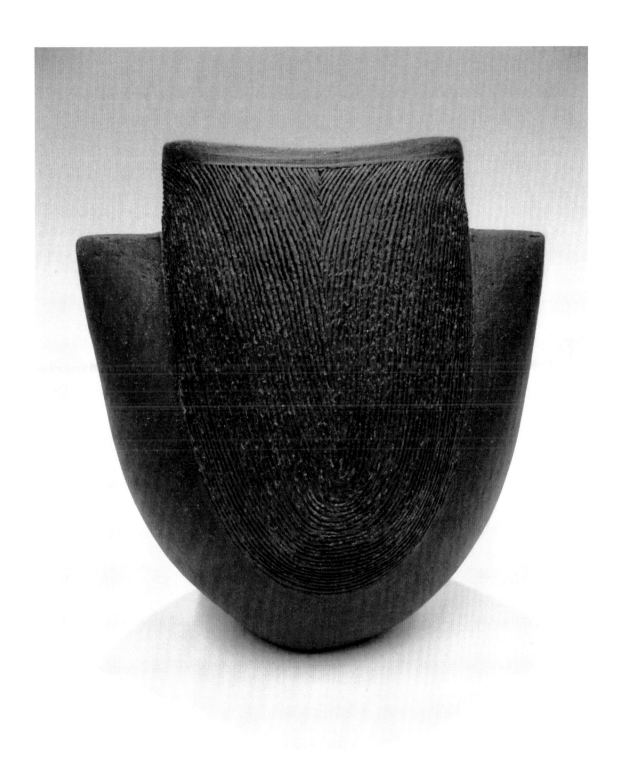

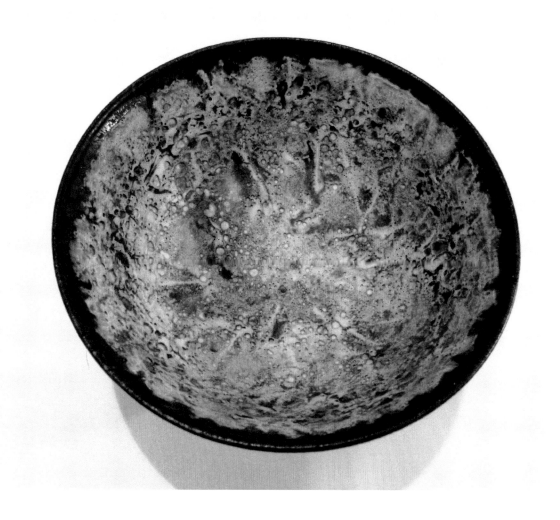

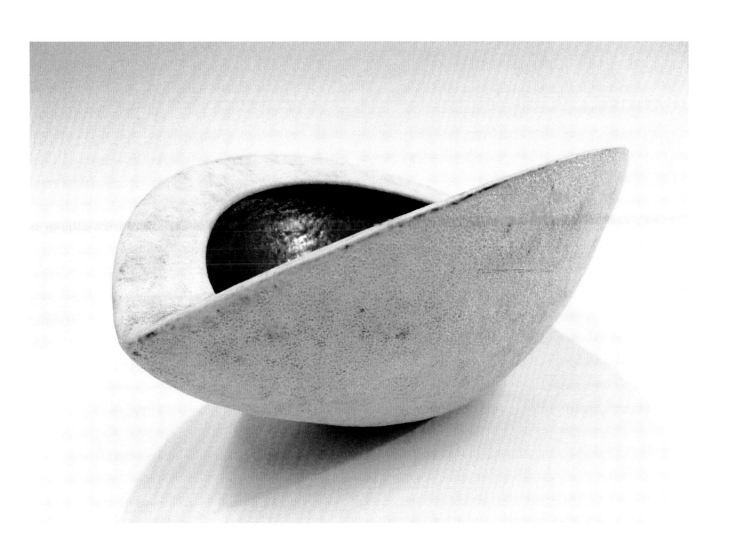

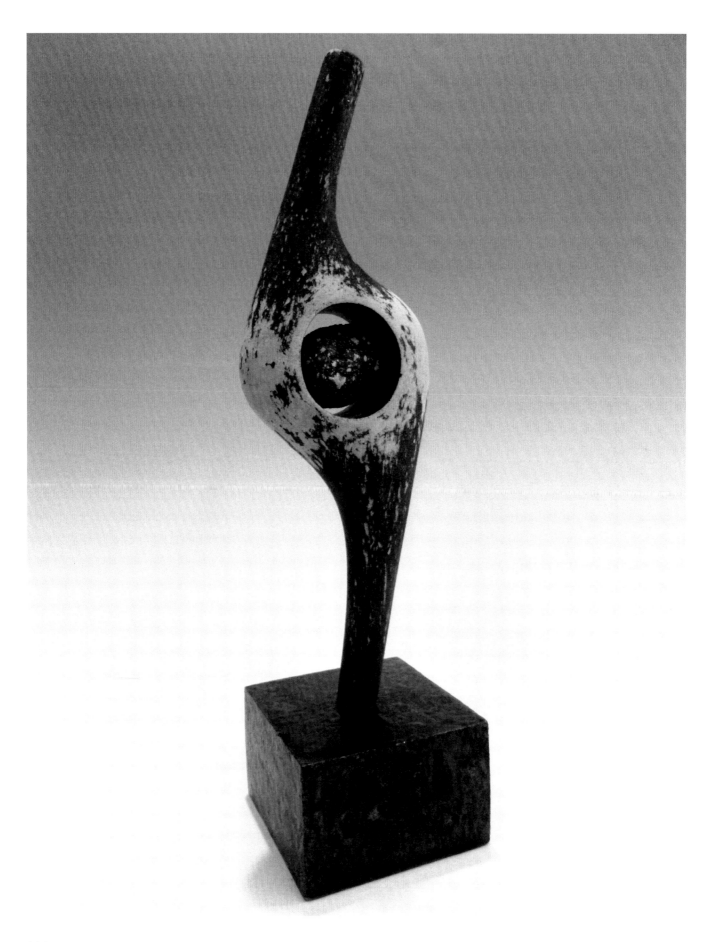

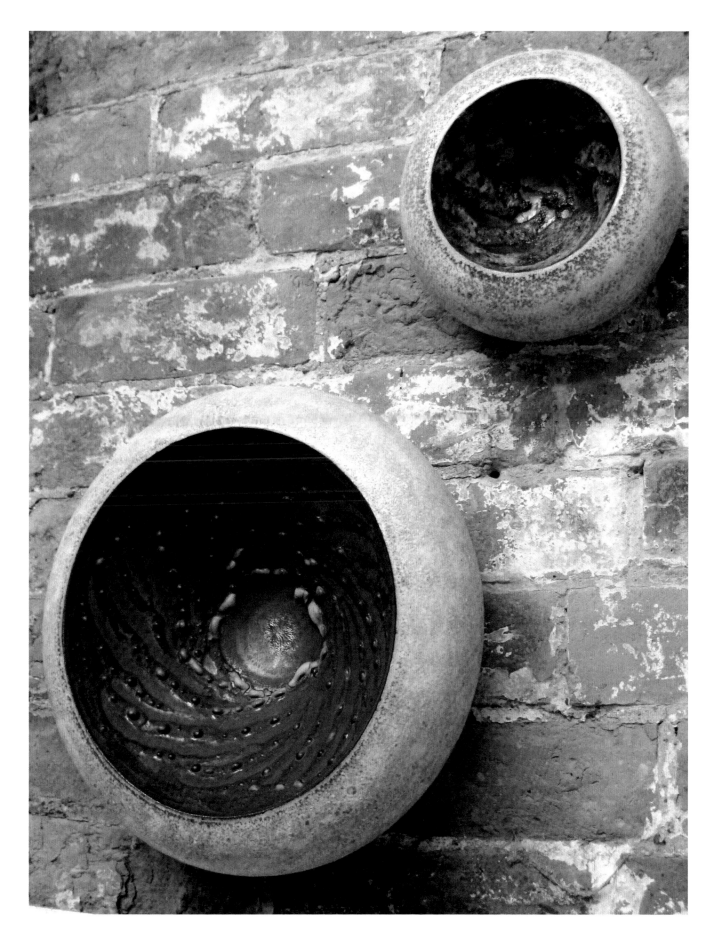

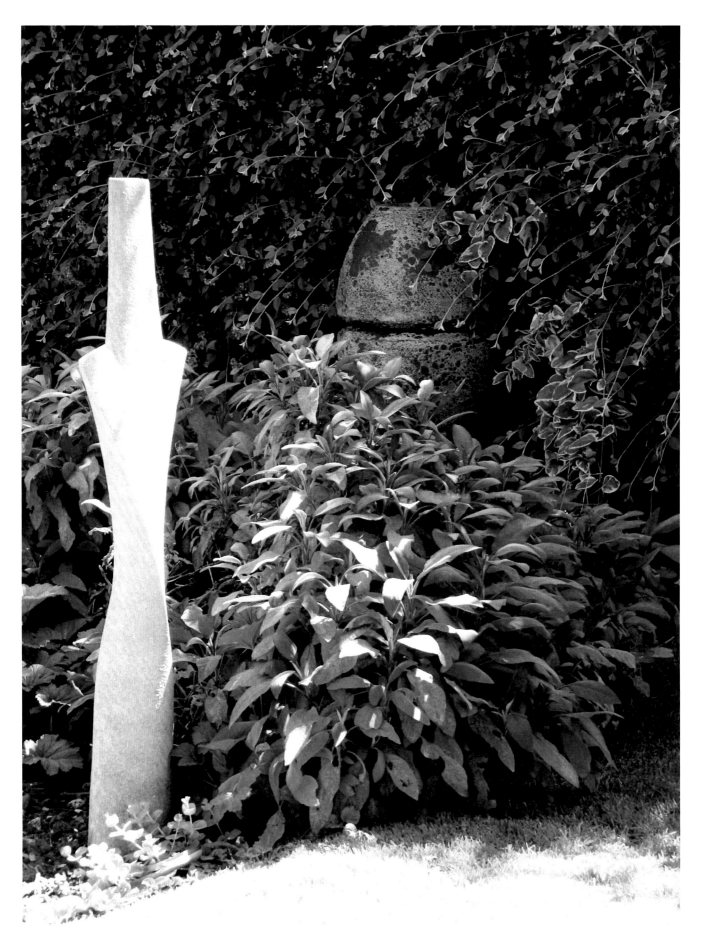

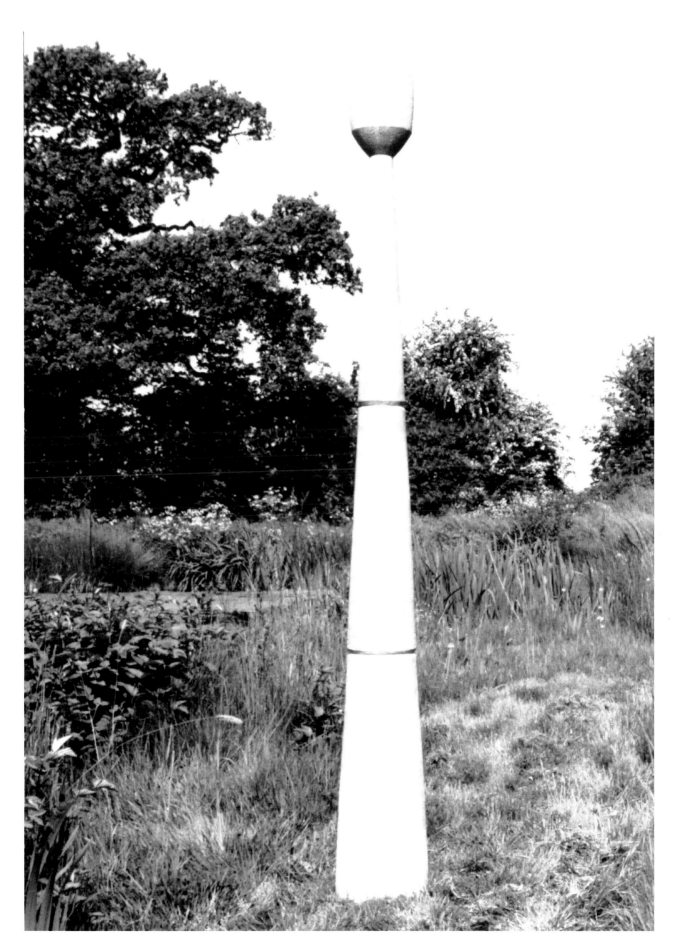

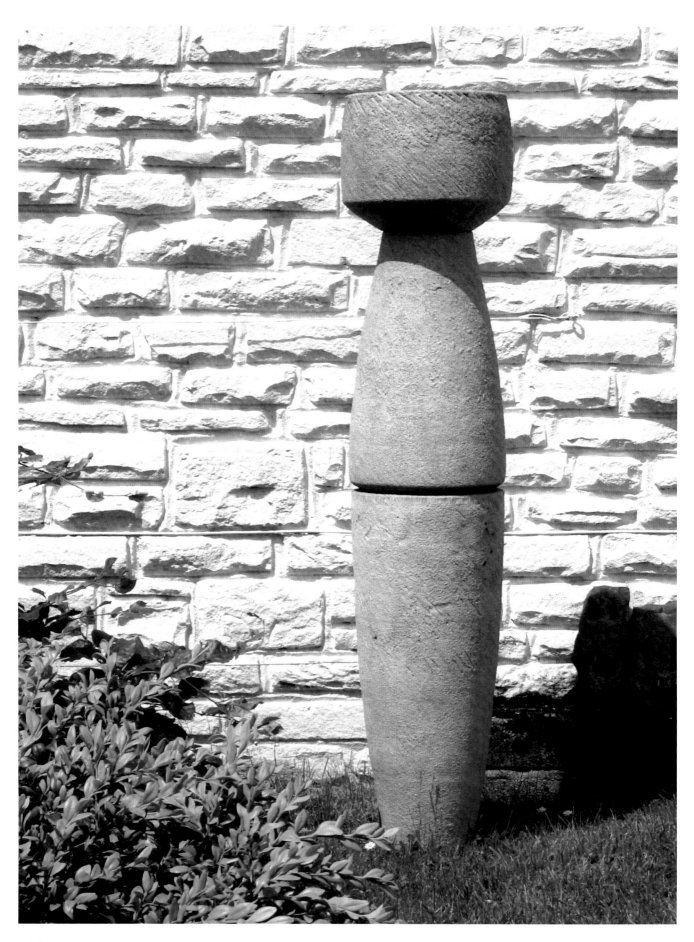

Just Pots: list of illustrations

List of illustrations from The Potter's Life, Talking about Making, and The Countryman Potter.